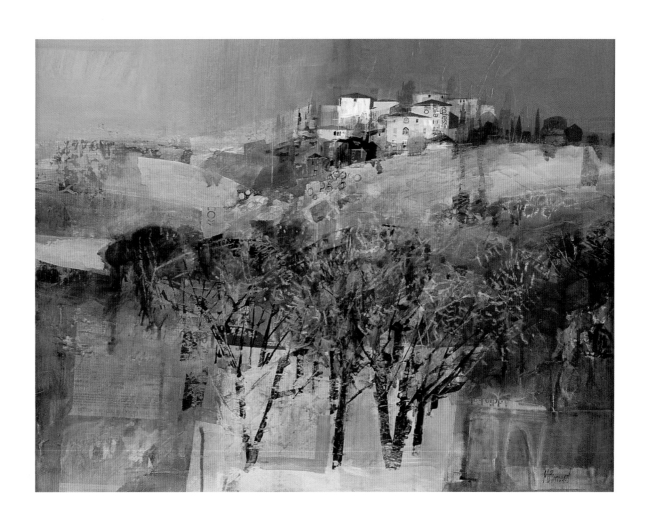

Collage, Colour and Texture in Painting

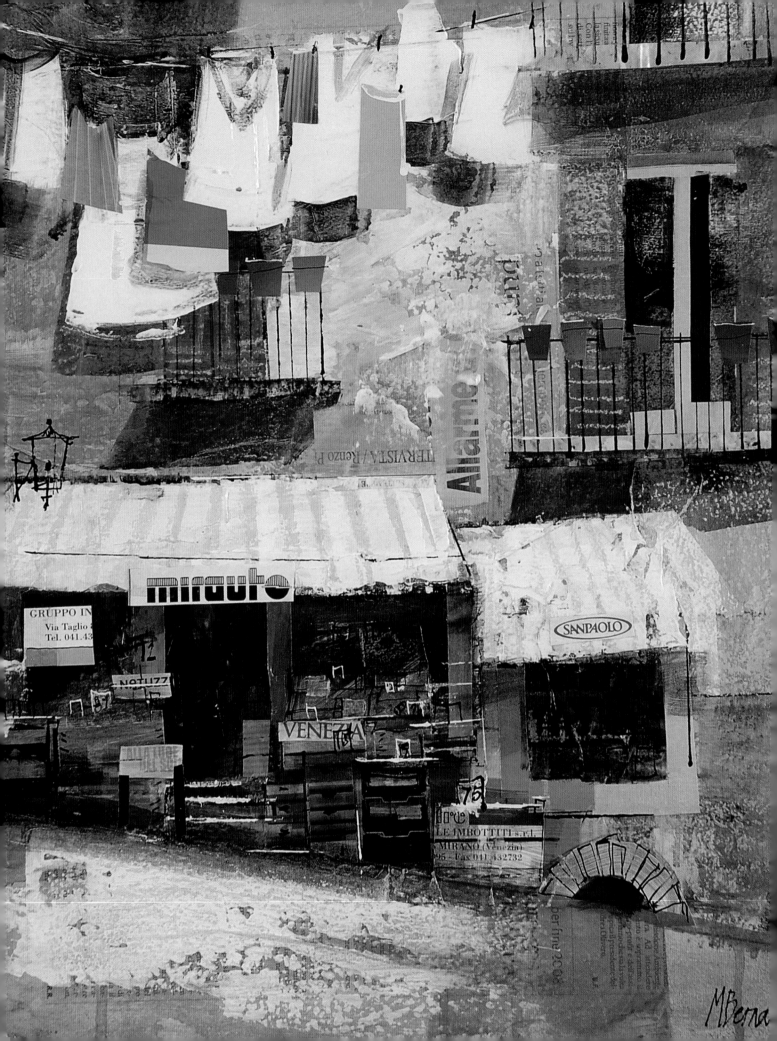

Collage, Colour and Texture in Painting

Mike Bernard and Robin Capon

BATSFORD

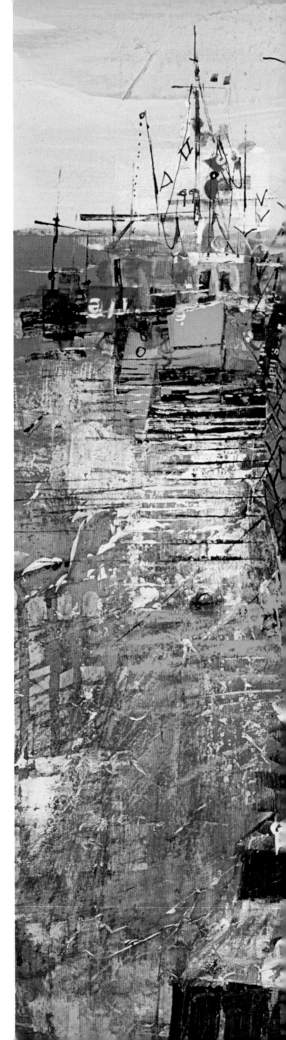

Acknowledgements

My sincere thanks to Robin Capon, for his insight and dedication in rendering my thoughts and ideas into a highly professional and concise text. My thanks, also, to photographers Michel Focard and John Andow, who have served me so efficiently in providing the majority of images for the book. Additionally, I should like to thank the many galleries that have shown my paintings and given me such great support, and especially everyone who has bought my work and so inspired me to carry on being creative.

Mike Bernard
www.mikebernard.co.uk
www.visitnutcombe.com

First published in the United Kingdom in 2010 by
Batsford
10 Southcombe Street
London
W14 0RA

An imprint of Anova Books Company Ltd

ISBN 9781906388577

A CIP catalogue record for this book is available from the British Library.

18 17 16 15 14 13 12 11 10
10 9 8 7 6 5 4 3 2 1

Reproduction by Rival Colour Ltd, UK
Printed and bound by Craft Print International Ltd, Singapore

Distributed in the United States and Canada by Sterling Publishing Co., 387 Park Avenue South, New York, NY 10016, USA

This book can be ordered direct from the publisher at the website www.anovabooks.com, or try your local bookshop.

Note: Except where otherwise specified, all the paintings reproduced in the book are made with mixed media, using a combination of collage, acrylic paint, acrylic ink and oil pastel.

half-title page: *Umbrian Landscape*
mixed media on mountboard
58 x 76 cm (23 x 30 in)

title page: *Village Shop, Cinque Terre*
mixed media on mountboard
42 x 35 cm (16 x 14 in)

right: *Harbour Steps, Lyme Regis* (detail)
mixed media on MDF
46 x 46 cm (18 x 18 in)

Contents

Introduction

From my experience when I used to teach, as well as from my own perception as an artist, I know that one of the most difficult aspects of painting is finding the most suitable and original way of expressing oneself. Each artist has a different view of the world and this should be reflected in a style of work that is distinctive and personal.

We all start by learning certain techniques and aiming to paint exactly what we see in the subject matter before us. And this is fair enough, because there is no substitute for developing the basic skills in drawing and painting, and consequently acquiring a degree of confidence. But how do we progress further and add that spark of individuality that takes our work beyond the ordinary and makes it stand out from the crowd?

Essentially, the form and impact of our work is influenced by two factors: our painting philosophy (what we regard as the important qualities to achieve in a painting), and practical issues (the materials and techniques that we choose to use). Having learned to paint in a conventional manner, many artists find it difficult to break away from that approach. But, in my experience, there comes a time when you have to reappraise both philosophy and technique in order to find a painting process that allows scope for personal expression and offers a good balance of challenges and rewards.

below: Mike Bernard in his studio.

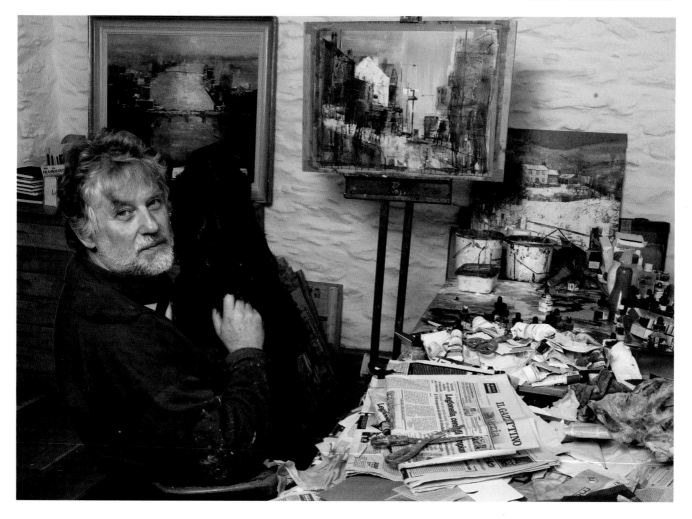

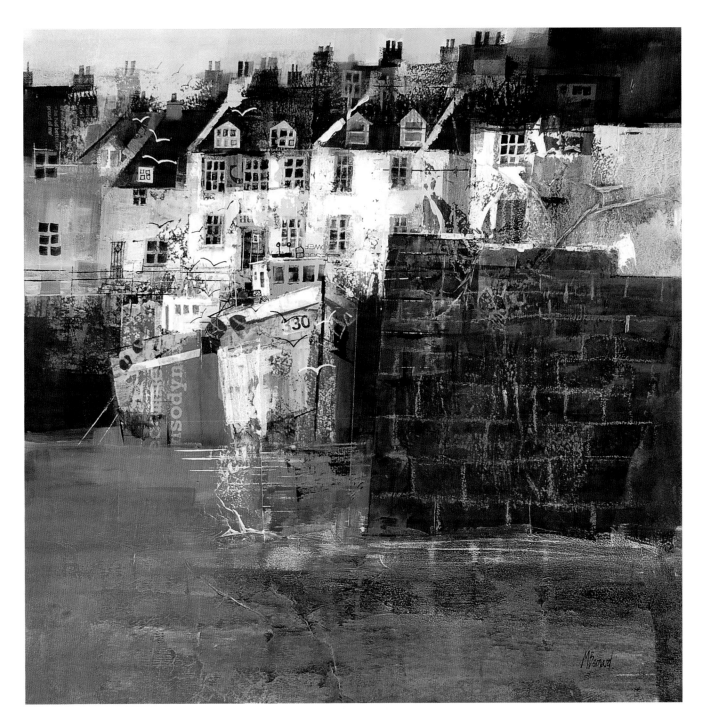

From the time I was at art college I have always felt that, rather than aiming to make an image that was completely faithful to the original scene, sketch or inspiration, it was more important to create an interesting painting. By this, I mean that the completed picture should be exciting to look at and have an overall coherence and impact. This does not necessarily preclude it from evoking a particular sense of place, of course, but it will show this with an emphasis on personal interpretation and will have been influenced by things that have happened during the painting process.

above: *Fishing Boats, Pittenweem*
mixed media on MDF
71 x 71 cm (28 x 28 in)
Uncomplicated paintings are generally the most successful. I usually work with quite a limited range of paint and collage techniques.

Creating your own interpretation of the subject matter – and so overcoming the belief that you must always produce a likeness of it – is something that I encourage throughout this book. It is a practice that is fundamental to painting, I believe, because surely the reason for painting is to express what you think and feel about things. And, as I have implied, this is inherently linked to the materials and techniques that you use.

When I was a student, dissatisfied with the lack of originality and impact in my paintings, I found that the solution was to set certain limits within which to work. Essentially, the limits were defined by the materials and processes that I allowed myself to use and, in turn, they created challenges and encouraged more intuitive, expressive paintings. In my view, uncomplicated paintings are generally the most successful: they have more vitality and, because they do not state everything in absolute detail, there is room for viewers to use their imagination. For many years now I have worked with a very limited palette of colours, using a combination of paint and collage techniques, and this has led to much more enjoyable and successful results. It is an approach that helps you to work with greater freedom of expression, and one that I can thoroughly recommend.

The way that you start a painting can have a tremendous influence on its ultimate success or failure. A common tendency is to do too much preparation, or start with too fixed an objective. Often, the blank white paper or canvas surface is another inhibiting factor. As discussed and demonstrated in the following sections of this book, I like to begin in a fairly spontaneous way, perhaps with random, abstract shapes of colour and texture. This has a very liberating effect and encourages me to continue to work freely, while respecting the demands of the painting itself. And, although I will have a particular place or scene in mind, I never allow that to dominate the painting process. What I strive for, and equally what I hope will inspire and help you in your work, is an approach that allows me to be true to myself and to paint with feeling and confidence.

right: *Evening, Piccadilly Circus*
mixed media on mountboard
38 x 53.5 cm (15 x 21 in)
Rather than aiming to create an exact likeness
of the subject matter, I think it is more
important that the painting itself is interesting
and shows a personal interpretation.

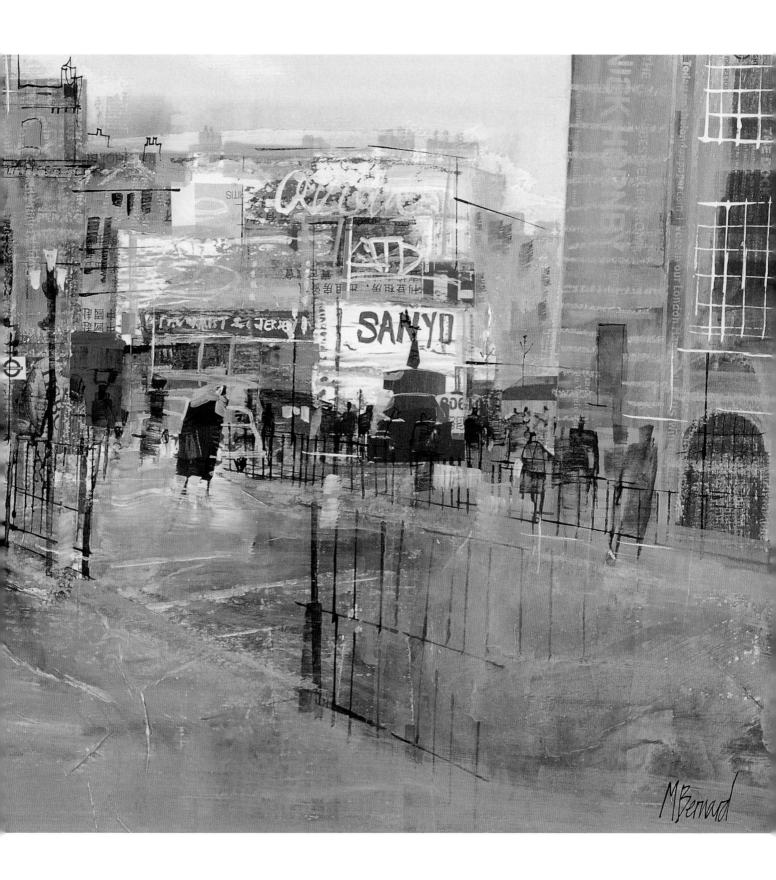

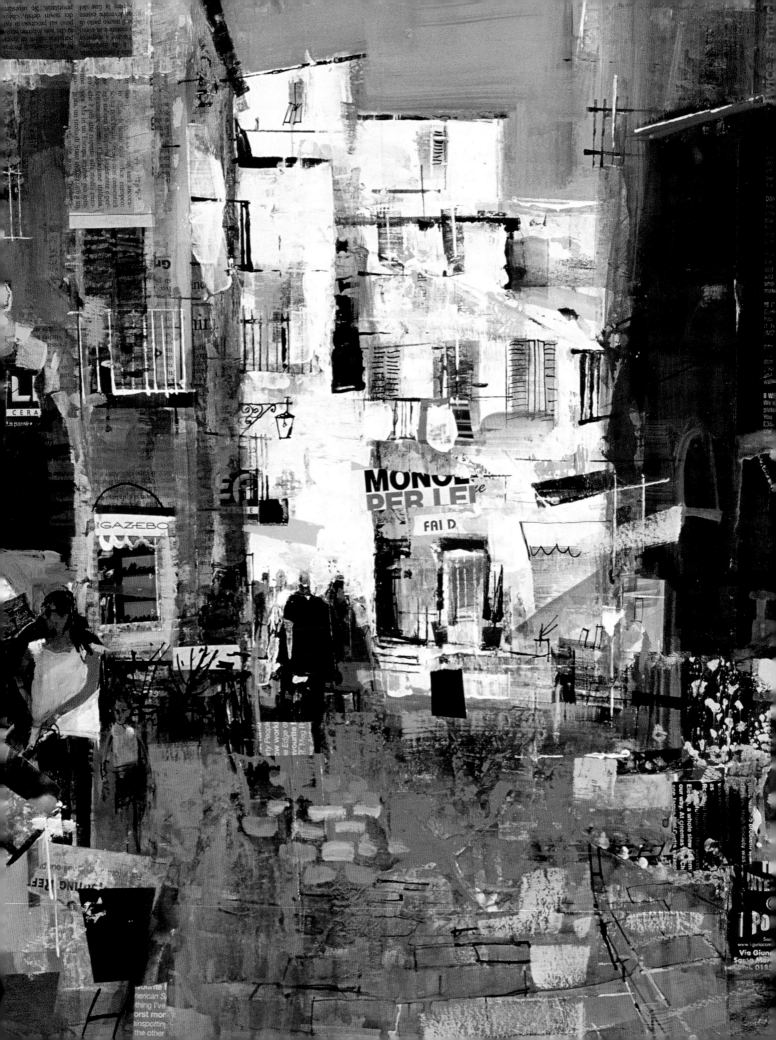

1 Starting Points

The starting point for all art is inspiration: this is a vital factor in creating work that has conviction, feeling and impact. For me, the ideas for paintings come from my surroundings, and especially from harbours and coastal scenes. Perhaps this is influenced by the fact that I grew up near Dover in Kent, but I have always been attracted to the colours, shapes, light and atmosphere of the coast. In particular I like subjects in which there is an interaction, pattern or repetition of shapes – rooftops, windows, boats, sails, masts and so on. Invariably, it is this aspect of a subject, combined with the overall sense of place and the experience gained from being there, that inspires me to paint it.

Inner Harbour, Mevagissey (below) is a good example of the type of subject matter that I find exciting and challenging. It involves man-made, almost abstract shapes which, in their repetition, create a sense of unity and coherence in the composition. At the same time, with its contrasts of scale and colour, the pattern of shapes adds variety and interest. Note how I have exploited the boat, mast, tyre and house shapes as compositional elements. I never feel limited by what is actually there: once I have been inspired by a subject I am prepared to embellish and interpret it as required, depending on the needs of the painting. I sometimes add more shapes, or leave things out. The strength and impact of the composition is the most important factor, rather than a feeling that I must adopt a totally representational approach.

Similarly, in *Shopping in Monterosso, Italy* (left), you can see that the underlying design of the painting is essentially a pattern of abstract shapes – mainly squares and rectangles. Markets and town scenes like this are other subjects that often feature in my work, and for the same reason as the harbours – because of their inherent sense of pattern, colour, activity and mood.

Alongside inspiration, motivation is an important factor. Finding an exciting subject is all very well, but the drive and determination to develop it into a successful painting is equally necessary. In the main, painting is a solitary activity and it requires a lot of self-discipline and perseverance. Often, one painting will inspire you or lead quite naturally to other ideas, and this in itself is a strong motivating force. And, as I have found, the deadlines for exhibitions will also encourage a steady resolve to follow ideas through to a satisfactory conclusion!

left: *Shopping in Monterosso, Italy* (detail)
mixed media on mountboard
46 x 54.5 cm (18 x 21½ in)

below: *Inner Harbour, Mevagissey*
mixed media on mountboard
46 x 61 cm (18 x 24 in)
The subjects that I enjoy most include a pattern of shapes, which will give unity as well as variety and interest.

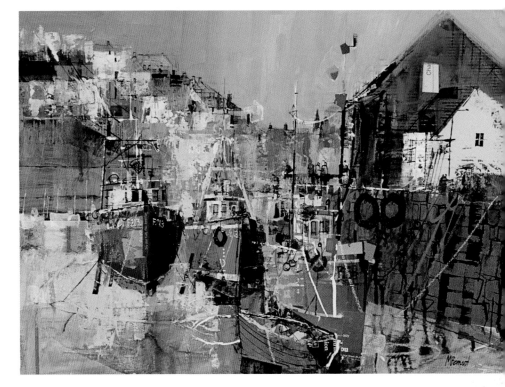

Challenging ideas

Every new painting is a fresh challenge, and this is particularly true if an aspect of
the subject matter or the method of tackling it is in some way different to anything
attempted before – and consequently is going to fully test your skills and ingenuity.
In my view this is what should happen in every painting, because essentially it is the
courage to try out new ideas, techniques, colour mixes and so on that leads to
increasingly confident, varied and successful work.

I am always ready to consider different types of subject matter and approaches.
For instance, now that I live on the edge of Exmoor, in Devon, farms offer a new
source of subject matter – see *Exmoor Farmhouse* (below). However, as well as painting
completely new subjects, I also enjoy the challenge of reinterpreting an image that
I have already used. There are some London scenes that I have painted in this way,
for example. I take the essence of the subject, but try a different composition, colour
scheme or mood for the painting.

below: *Exmoor Farmhouse*
mixed media on mountboard
35.5 x 48 cm (14 x 19 in)
I am always looking for new sources of
subject matter and, since moving to North
Devon, I have begun to explore the
potential of farms as another different and
challenging starting point for paintings.

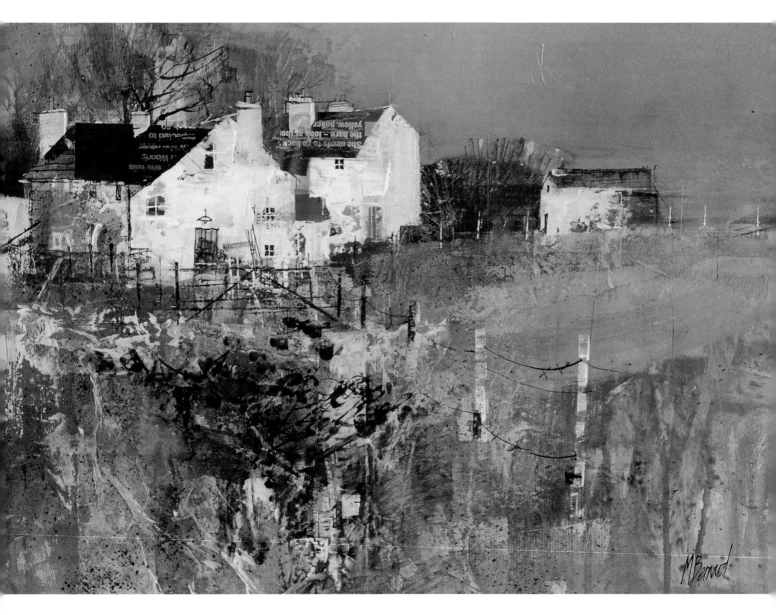

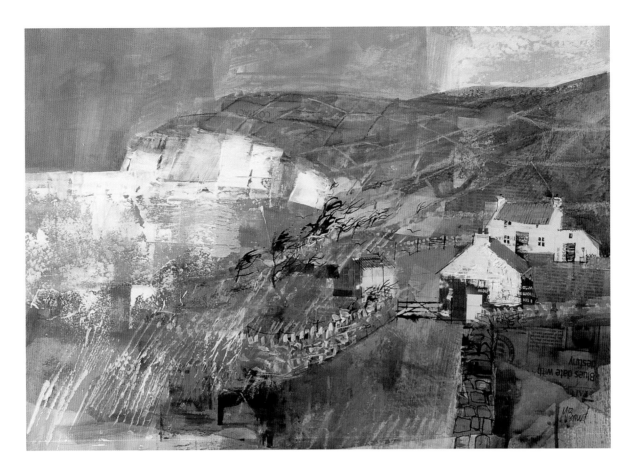

above: *Coastal Farm, Ireland*
mixed media on mountboard
46 x 62 cm (18 x 24½ in)
With this subject, I was attracted by the
pattern of fields together with the contrast
of man-made and natural shapes.

Also, there are times when the first attempt at an idea does not work as well as I would like, and therefore I try it again, using a different approach and emphasis. Or, while I am painting, I become aware of other possibilities for the subject, which may lead to further paintings based on the same theme. In fact, that is one of the aspects of painting that I find most exciting: you never quite know what is going to happen or when you will create a new and particularly interesting texture, effect or other quality that will contribute to your knowledge and experience, and further encourage you to try new challenges.

Shapes, colours, textures

I know, from my own experience as a student at art college, that if you work without a considered focus or sense of direction in your paintings, it is very difficult to reach a successful result. At that time, I found it difficult to finish paintings, and I would become frustrated and disappointed because I could never quite achieve the sort of impact and style of work I had in mind – it was restricted by conventions and the assumed need to work in a representational manner. I wanted somehow to overcome an inherent concern for the reality of the subject matter, and so create paintings that were more personal and interesting.

The answer, I found, was to keep within certain parameters for each painting and set clear objectives. In response to the way that a painting is developing and the chance things that happen, it is easy to lose track of your intentions for the work and veer off in a different direction. This can result in confusion and a finished painting that lacks coherence and impact. Instead, to encourage success, you must keep in mind what you initially aimed to achieve in the work and follow that aspiration.

Of course, adjustments are always necessary to a painting as it progresses, and you may want to take advantage of fortuitous textures and other 'happy accidents' that may happen during the painting process. But again, such decisions should be made with regard to your objectives for the work and how they will influence and hopefully enhance the result. For me, the essential elements to consider are shapes, colours and textures. I want each of these elements to work independently – so that the shapes, for example, are interesting and create a dynamic composition – but equally, to produce a coherent and successful painting, they must complement each other.

Generally, I think paintings work best if they are uncomplicated, and this particularly applies to the use of colours. I learned that if you initially limit your palette and keep to those few colours, it helps to create a feeling of unity in the painting. Also, I found that a choice of perhaps just two colours led me away from thinking that I must only work with the colours that are actually there, in the subject matter. Therefore, if I chose perhaps a blue with a brown/red, for example, it not only helped me use colour more expressively, but also automatically introduced its own mood and sense of harmony in the painting. In turn, this encouraged me to involve collage and textures, and so produce work that had a more abstract quality.

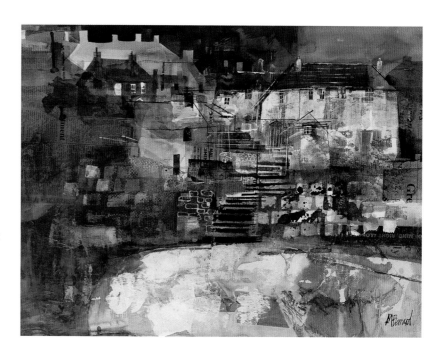

above: *Harbour Steps, Coverack*
mixed media on mountboard
47 x 61 cm (18½ x 24in)
As here, it is always colours and textures that are the raw elements of a painting. They must work independently, but also in such a way that they complement each other.

Vision and design

The content and design of a painting are obviously very important aspects to consider right from the start, and in doing so, choosing the focal point (the area or individual object within the composition that creates a focus of interest) is, in my view, the most crucial decision to make. Having found a subject to paint, I invariably begin by planning where the focal point will be. It could be a distant house, for example, a figure, or even a dramatic passage of light, colour or texture. To help make that decision, I sometimes use a cardboard viewfinder to 'frame' the subject I have in mind and so enable me to assess more clearly the relationship of the main shapes.

I seldom move the position of the focal point once the painting is in progress. However, I might change its size, shape or colour, or even what it is, depending on the development of the painting. For example, having started with the idea that the focal point will be a red boat, because of other considerations within the painting or perhaps as a result of a happy accident, I might decide to leave it as a sparkling patch of light. The confidence and ability to make this sort of decision are qualities that gradually develop from experience.

In fact, when we first start painting there is a tendency to be very faithful to what is seen: we feel obliged to include everything and match the colours as accurately as we can. We soon learn, however, that this is seldom good practice when it comes to composition, because usually there must be an element of selection regarding the content and organization of the painting if it is to succeed as an image with some

originality and impact. But having taken certain decisions about selection and simplification, there can be problems in deciding how to deal with those areas in which alterations have been made – if you choose to leave out something from the original subject matter, what do you replace it with, for example?

Again, experience helps in overcoming those problems. If I need to simplify the content in certain areas I often – because of my interest in surface qualities – rely instead on an appropriate handling of colour or textural effects. In the same way, if I feel that there are parts of the composition that should be more exciting – perhaps a large, empty foreground area – I might introduce some collage or similar surface interest. Usually, the main areas to simplify and leave as such are those around the edges of the composition. It helps to have the edges less 'busy', so that the viewer's interest is contained within the painting, rather than have the eye drawn to the outside. Some of these points are demonstrated in *Harbour and Rooftops, Mousehole* (below). Note how the empty foreground area on the left is enlivened through the use of texture and colour variations, and how the overall colour palette has been simplified, with the main area of interest placed centrally.

below: *Harbour and Rooftops, Mousehole*
mixed media on mountboard
51 x 65.5 cm (20 x 25½ in)
Generally, I like to work with a simplified colour palette, concentrating the main area of interest towards the centre of the painting.

Places

Although I do not usually stay at locations for very long, and although I often make radical changes to the subject matter as seen, usually the inspiration for my work comes from visiting different places. One of my favourite areas is Cornwall. Since our first family holiday there some years ago, I have returned regularly. I particularly like the small fishing villages and harbours in Cornwall, as these have all the elements (in shape, colour and texture) that I enjoy working with in paintings.

Similarly, in Italy and the south of France, it is the harbours and markets that attract me. And while I am not overly fond of cities, I still find lots of ideas in London, various parts of which I got to know quite well when I was a student at the Royal Academy. What I especially like about the towns and harbours is the potential for bold shapes and colours that they offer in the different man-made objects – the buildings, buses, boats and so on.

below: *Siena Rooftops*
mixed media on MDF
66 x 91 cm (26 x 36 in)
Here again there are repetitive shapes – the rooftops – which give rhythm and harmony to the composition.

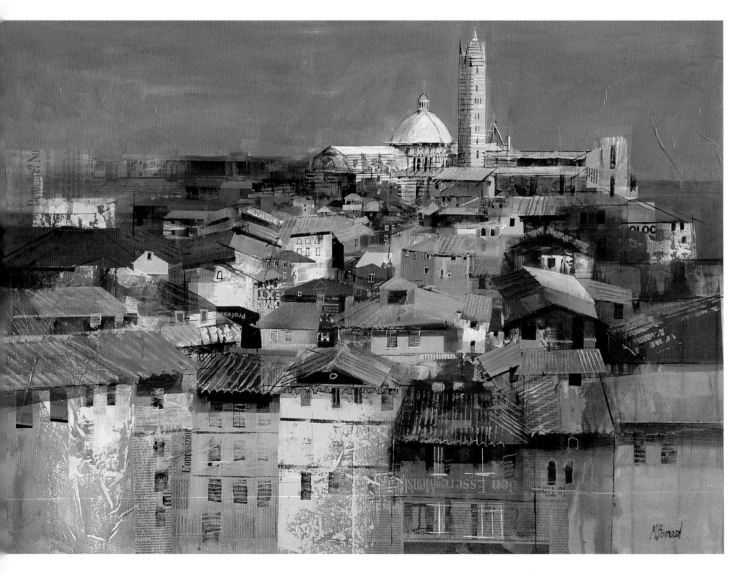

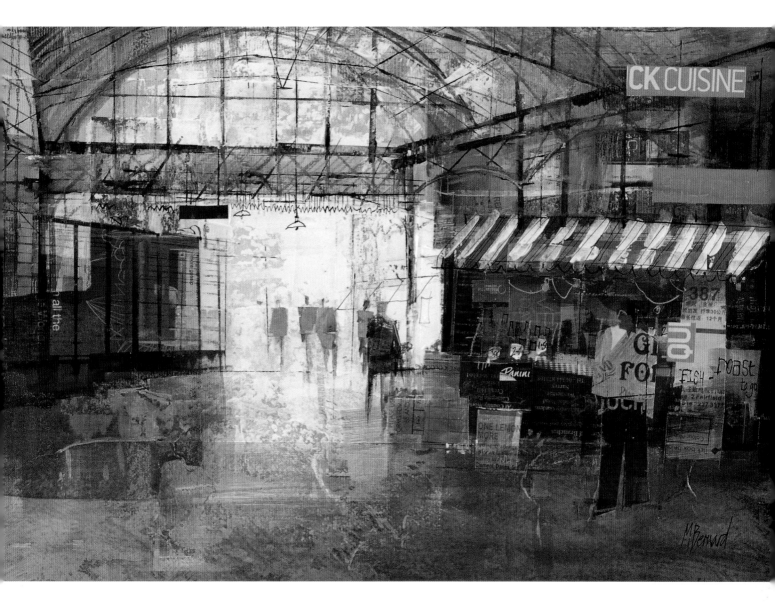

Exciting locations

While I value the stimulus of new places, I know that equally there can be an advantage in returning to a familiar location and building up a greater knowledge and appreciation of it. I am often amazed, when I go back to an area, to find how it can look so exciting and different to the way that I remember it. And of course, an identical scene to one that I have painted before can take on a quite different atmosphere and impression, depending on the season of the year, time of day, light, weather and so on. Returning to a place and experiencing its different moods can be very inspirational and motivating, and I quite understand how Cézanne, Monet and other artists could go back to a subject many times without losing the feeling of vigour and expression in the finished paintings. It is easy to forget, I think, just how inspiring some places are!

On painting trips I make sketches, take photographs and collect all the information necessary to work on a series of paintings later, back in the studio. But as well as these planned trips, there are times when, quite by chance, I find I am somewhere that inspires an idea for a painting, and in which case I have to rely only

above: *Interior of Borough Market*
mixed media on mountboard
35.5 x 51 cm (14 x 20 in)
Markets have always been one of my favourite subjects, particularly when there is a strong sense of structure and various inherent abstract qualities to work with.

on photographs or my memory. *Trafalgar Square in the Rain* (below) was conceived in this way. I was in London, but had not taken any sketching materials or gone with any expectations of finding subjects to paint. But when I came across this very atmospheric scene, with all the umbrellas and the wet pavement, I knew it was something that I must paint.

In contrast to most of my paintings, in which the mood is achieved mainly as a consequence of the process and techniques involved, in this painting I was driven more by a desire to recapture the actual sense of place and what it felt like to be there. The

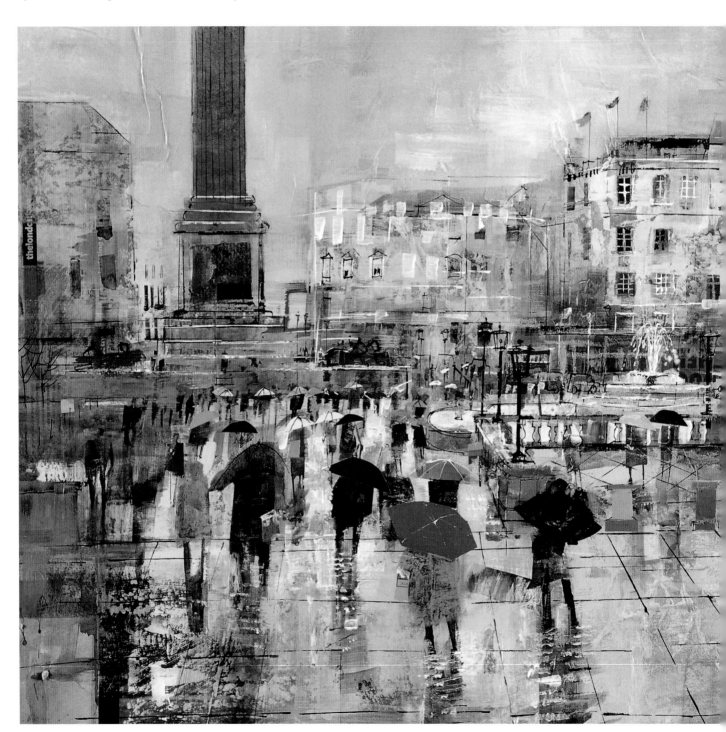

main challenge was how to suggest the wet, reflective pavement, without being too literal. It was an effect that I had never tried before, but in the event it suited my usual way of working, which essentially relies on wet-into-wet applications of acrylic colours.

Again, for the painting of *Winter Light, Bucks Mills* (below), the starting point was a photograph – in this case a very poor photograph – but in contrast to *Trafalgar Square in the Rain*, the emphasis was very much on interpretation rather than working from the scene as observed and experienced when I was there. I never let photographs dictate how I should use shapes and colours, and for this painting I decided that I would keep to a very limited palette of greys and focus on the effects of light, particularly on the rooftops, to convey a cold, wintry mood.

left: *Trafalgar Square in the Rain*
mixed media on mountboard
51 x 71 cm (20 x 28 in)
It isn't always possible to make adequate sketches on site, so try to develop a good visual memory. I painted this subject from photographs and my imagination, and by recalling my own experiences of the scene.

below: *Winter Light, Bucks Mills*
mixed media on canvas
61 x 61 cm (24 x 24 in)
If I start from a photograph, I never let it dictate how I should interpret the subject. In this painting, I wanted to create a particular effect of light.

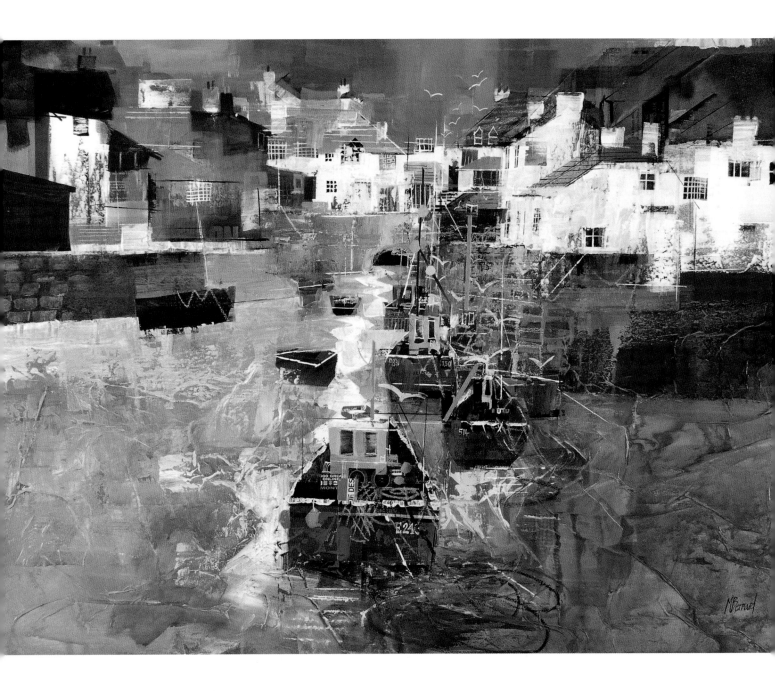

Subjects and potential

The amount of preparation and planning required before starting a painting is a matter for individual judgement. Some artists like to have the composition, colour scheme and similar key aspects of the painting well resolved before they make a start, while others prefer a more spontaneous approach. In my experience, the best approach is usually something in between these two extremes: you need to do enough planning to enable you to work confidently and with clear objectives, but on the other hand not prepare so thoroughly that there is nothing left to explore in the painting, with the consequent danger that it will look dull and uninspired.

In effect, the planning starts with the initial assessment of the subject matter and whether you think it has the potential to make an exciting painting. The subject matter doesn't have to be perfect as it stands, but, perhaps with a degree of

above: *Red Fishing Boat, Polperro*
mixed media on canvas
76 x 101.5 cm (30 x 40 in)
In creating a strong composition, selection and simplification are usually an essential part of the process.

simplification or invention, will offer scope for individual interpretation. My preference is for subjects that have a strong, underlying sense of the abstract.

In *Red Fishing Boat, Polperro* (left), for example, the composition relies on a pattern effect that was built with different-sized squares and rectangles made by greatly simplifying the main shapes within the subject matter, the boats and buildings. And, as you can see, I have also exploited the contrasts in the size of these shapes to create a sense of depth and perspective in the painting. With this sort of painting, I love the way that you can play with silhouetted and overlapped shapes to add to the interest and dynamics of the design. Notice also how it only needs a suggestion of recognizable forms in a painting – in this case the ropes, masts, windows and chimneys – to give it a sense of reality. Polperro is a place that I know very well, and because of this I no longer feel restricted to faithful representation. The familiarity helps me work with much greater freedom.

I have adopted a more graphic approach in *Market Stall* (below), flattening out the shapes and giving quite an abstract feel to the painting. Again, the shapes are simplified and essentially the design is based on a considered arrangement of rectangular blocks or divisions, allowing scope for different textures. Naturally, because of the way I work, with perhaps twenty paintings in progress at the same time, ideas filter through from one painting to another – perhaps the use of a particular colour or, as here, silhouetted shapes. My working process is influenced by the fact that, at some stage, each painting has to be left to dry, and when that happens I switch to another one.

below: *Market Stall*
mixed media on mountboard
15 x 30.5 cm (6 x 12 in)
Sometimes I introduce a more abstract quality to the painting by both simplifying and flattening out the main shapes within the design.

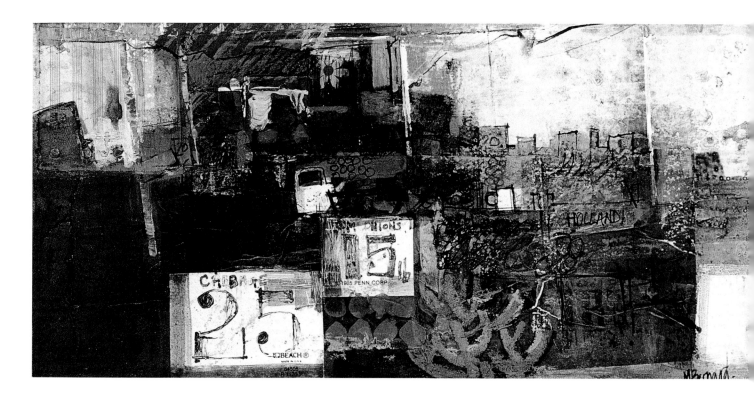

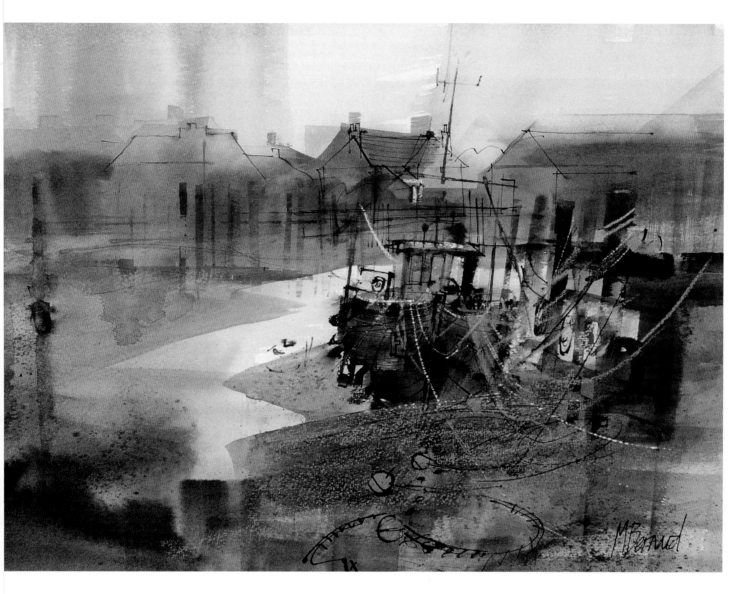

I began with a pencil drawing, and then added the blocks of colour before completing the sketch with further lines and shading made in pencil.

One of my favourite sketching techniques is pen and wash. I like the fact that it enables you to combine specifically drawn shapes with a sense of mood and atmosphere in the sketch. Again, I work on a Not watercolour paper, and for this technique I normally start with some broad washes of colour applied wet into wet. Then I quickly draw into these with a dip pen and some black Indian ink or coloured acrylic ink. Sometimes I spray the paper first – using an ordinary plastic plant-sprayer filled with clean water – to produce a diffused, atmospheric colour effect. *St Mary's Market* (page 25) is an example of this technique.

Similarly, for *Fading Light, Emsworth* (above), I worked on damp paper to help create the misty, low-light effect. Here, the colour washes were made from very diluted acrylic inks, keeping to an almost monochrome palette of greys and browns. The pen lines add the necessary drawing and definition, as they do in *Hampshire Lane* (page 25), in which I have introduced touches of white gouache, masking fluid and candle wax to suggest different textures.

above: *Fading Light, Emsworth*
dip pen and black and sepia acrylic
ink on Not watercolour paper
30.5 x 40.5 cm (12 x 16 in)
In this sketch I started by spraying
the paper with clean water. While
the surface was still damp, I added
the basic colour washes, before
drawing with pen and ink.

Composition studies

Having returned to the studio with the sketches made on location, the next stage in my working process is to decide which ideas look the most promising for developing as mixed-media paintings. I look at the sketches in turn, and for each one that interests me I make a sequence of small studies, as shown below. Working with just the main elements of the subject matter, I try out different sizes and shapes for the painting as well as exploring how I can create the most effective composition. I might decide to focus on just part of the location sketch and develop a painting from that, or perhaps expand the original idea in some way.

This process is especially useful when I am working towards an exhibition. It helps me plan the overall content and arrangement of the exhibition, and if necessary devise the content to fit a particular theme. From the series of small studies, I pick out the ideas that will suit the two or three major pictures around which the exhibition will be built, and incidentally it is these more challenging paintings that I normally concentrate on first. Also, there is a practical advantage in making composition studies, in that I am able to judge the number, sizes and shapes of the painting boards that I need to prepare.

below: *Composition Studies*
fibre pen on cartridge paper
30.5 x 46 cm (12 x 18 in)
In the studio, I usually begin by making a sequence of simple sketches to explore different composition ideas.

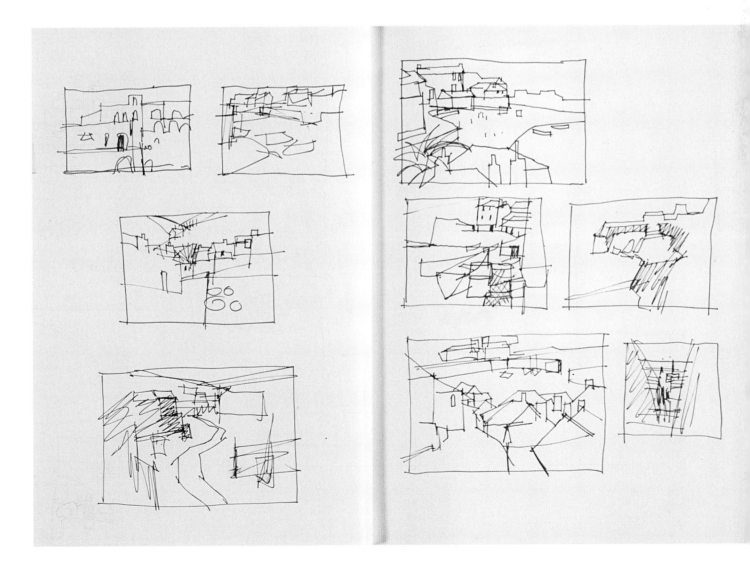

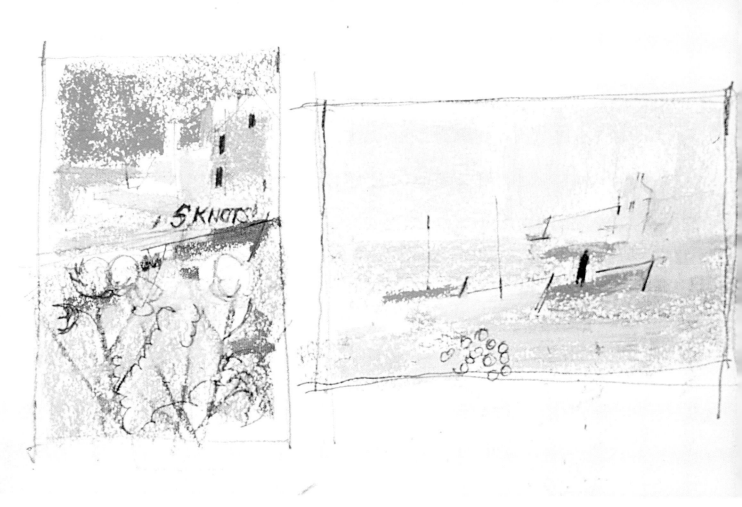

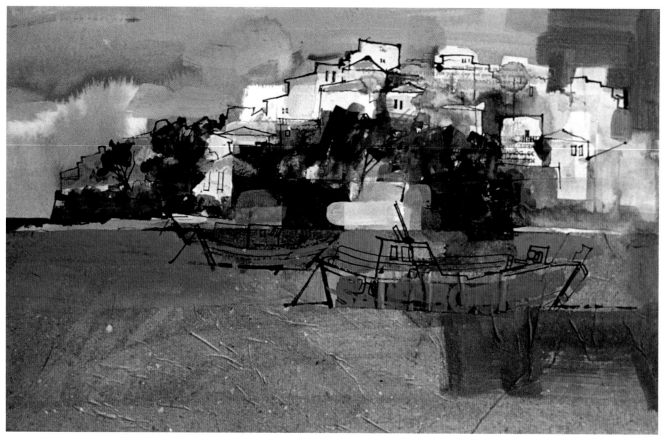

Initial shapes

When I start painting, the small sketches help most in showing the important divisions within a composition – the main vertical and horizontal lines and shapes. In the sketch, these elements are greatly simplified and look quite abstract; but, when developing a strong vertical in the painting, for example, it might result as perhaps the mast of a boat or the side of a building. However, I only regard the sketch as a guide, and I never start by making a specific drawing on the board or card support.

Methods of working vary, of course. Some artists like to begin with a careful drawing on the support and they keep precisely to that design as the painting is developed. Essentially, the approach will depend on the aims for a painting and whatever creates the confidence to make a success of it. Personally, I like to keep the options open, which is why I usually start with torn collage rather than a drawing. And, instead of relying on detailed preparatory studies, I prefer to resolve things as necessary during the painting process.

left: *Sketches*
chalk, pastel and pencil on cartridge paper
20 x 15 cm (8 x 6 in) and 25.5 x 18 cm (10 x 7 in)
Occasionally, I make one or two quick colour studies to get a feel for the overall content and composition that I might use.

left below: *Skiathos, Greek Islands*
mixed media on mountboard
30.5 x 46 cm (12 x 18 in)
I often use a dip pen with acrylic ink to add the necessary degree of definition to a painting.

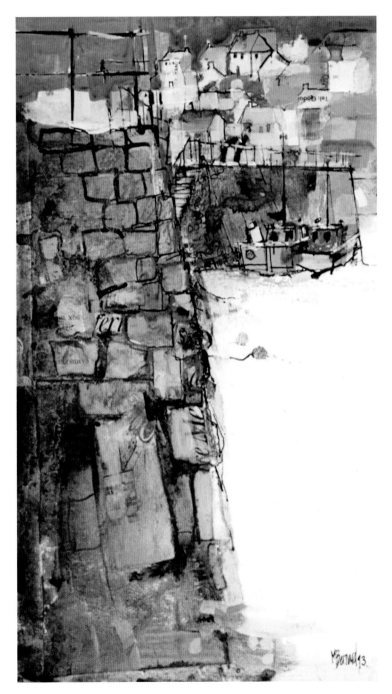

right: *Harbour Wall, Mousehole*
mixed media on mountboard
38 x 19 cm (15 x 7½ in)
Here again, it is the pen lines that pull everything together and give meaning and interest to the work.

Painting and composition

The composition – the choice of subject matter and the way that it is arranged within the picture area – is one of the most significant aspects of the painting process. If the basic structure is weak, and thus does not result in a visually interesting and coherent design, then, no matter how skilfully the subject is painted, the impact will be greatly reduced. For me, composition is essentially about proportions and divisions, especially the relationship of horizontal and vertical shapes and lines and the places where these meet and cross each other. Also, within the composition, it is important to consider the balance of busy areas and quiet areas, I think.

Sometimes I use quite a complex arrangement of verticals and horizontals, as in *Jetty, Walberswick* (below), for example. Here, to suit the content and create the greatest impact, I felt that the subject needed a long, horizontal composition. In fact, to create the framework of the jetty, I added lines across the background area, using a length of card dipped in black acrylic ink. But equally, as I developed this structure of intersecting vertical and horizontal lines, I was aware of the 'negative' shapes. In any composition it is always important to consider the spaces between the main shapes as an integral part of the design. It is often the 'negative' shapes that add energy and tension to a design.

In composition, as in all aspects of painting, intuition and personal preference usually play a part. But whatever the approach, a successful composition will always depend on getting the key elements in the right places and creating an effective contrast and balance of shapes. Because I like to start my paintings in an uninhibited way, with collage and washes of colour, the composition evolves rather than follows a set plan. However, it is interesting to note that in most of my finished paintings there are some similarities in the way that I have eventually organized the main divisions

right: *Deckchairs, Beer*
mixed media on mountboard
38 x 56 cm (15 x 22 in)
Interestingly, most of my compositions are loosely based on the Golden Section. For example, note where I have placed the horizon line in this painting, and also the position of the cliff edge.

below right: *Borough Market*
mixed media on canvas
71 x 71 cm (28 x 28 in)
A square format is ideal for some subjects, particularly if, as here, there is a play between horizontal and vertical elements.

below: *Jetty, Walberswick*
mixed media on mountboard
35.5 x 68.5 cm (14 x 27 in)
The size and shape of a painting are important aspects to consider. For this subject, I felt that a long, horizontal composition would work best.

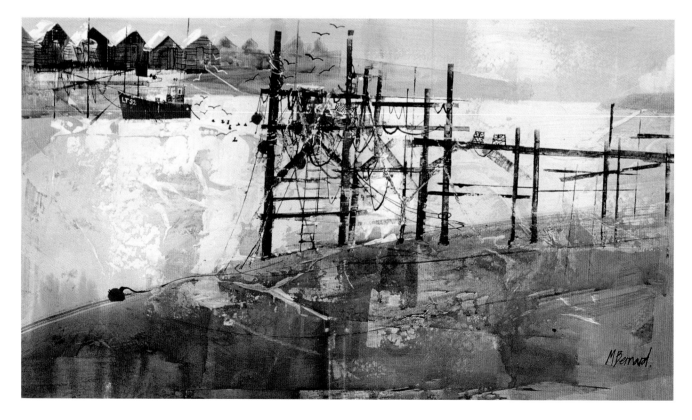

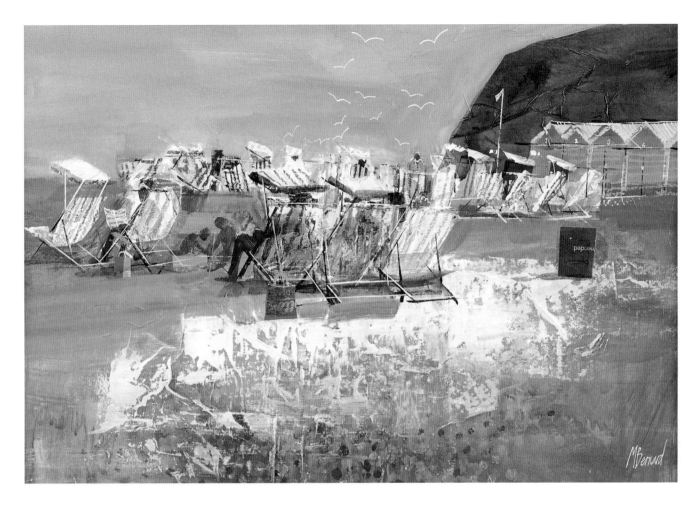

within the composition, and that these are loosely based on the Golden Section.

The Golden Section proportion is something that has greatly interested and influenced artists since Renaissance times. It is a proportion found in nature and which is generally accepted as having an inherent aesthetically pleasing quality. The ratio or proportion in the Golden Section is approximately 5:8, but this is usually further approximated in art and thought of in terms of thirds. In fact, artists often refer to this proportion as 'the rule of thirds'. When applied to composition, the 'rule of thirds' will give a division of the picture area – either vertically or horizontally – of one-third to two-thirds. In a landscape, for example, this could relate to the proportion of sky to land. Often, the position of the focal point in a painting is instinctively or deliberately devised with the 'rule of thirds' principle in mind, so that perhaps a tree, a figure or the edge of a building is placed at about one-third or two-thirds of the way across the picture area.

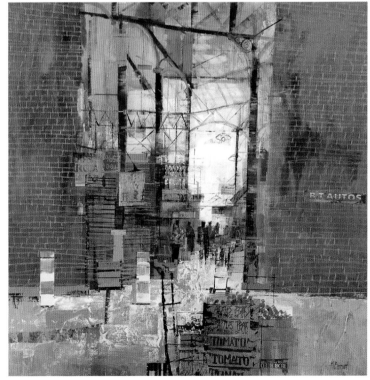

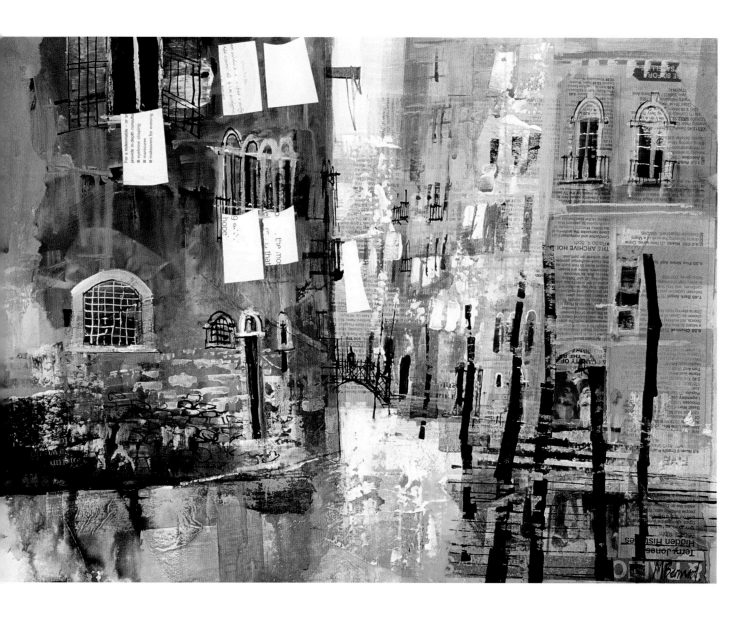

above: *Washing, Venice*
mixed media on mountboard
37 x 51 cm (14½ x 20 in)
To enhance the interest and coherence of the
composition, I often use 'follow-through' lines
in my paintings, as with the vertical poles and
their reflections in this example.

Focus and interest

A successful composition will hold the viewer's attention within the picture area and
be designed so that the eye is led to a specific point of interest. In my view, this need
not prevent paintings from implying that there is something connected or additional
happening beyond the picture area, as long as the composition itself holds together
as a coherent image. For example, in *Jetty, Walberswick* (page 30), the interest is
contained within the painting, but at the same time we cannot help wondering
about the rest of the jetty, beyond the right-hand edge of the painting. This sense
of intrigue can add to the dynamics and tension in a design.

Planning a composition involves various skills, one of the most important of
which is the ability to focus on the most useful elements of the subject matter and
translate those three-dimensional forms into basic two-dimensional shapes. This is an
aspect of composition that many inexperienced artists find difficult. My advice here
is to take some time over assessing the subject matter and then, from what you have
observed, explore its potential – in terms of design and the use of a flat pattern and
relationship of shapes – by means of sequential small sketches. As another way of

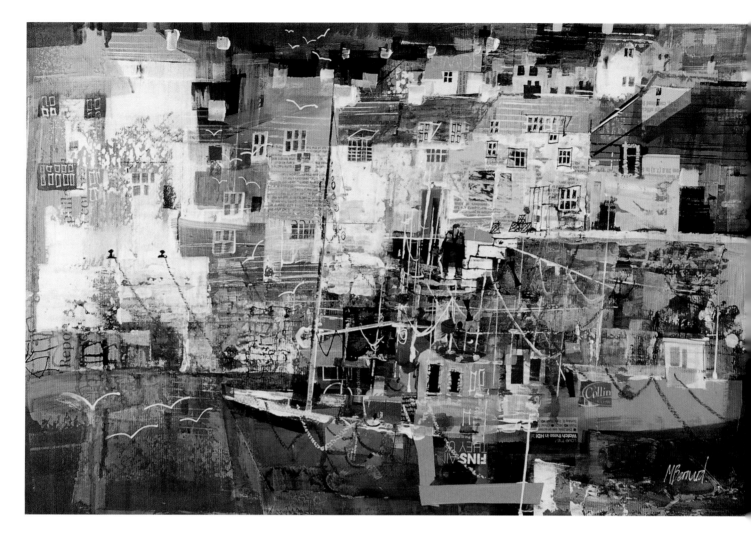

checking whether the composition works effectively, try turning the sketches upside down or looking at them as a mirror image. This is something I occasionally do when I am painting: I like to see the painting from an unexpected viewpoint, and this helps me decide whether the composition is interesting and powerful enough or whether I need to make any adjustments.

'Follow-through' lines are another feature that can add to the interest and coherence of a composition. For example, in *Washing, Venice* (above left), the reflections of the poles and the walls help link the lower part of the painting to the rest. Quite often in a painting I will extend a vertical line – perhaps the edge of a wall – upwards or downwards to create a follow-through in the composition. Working with mixed media, it is possible to make adjustments like this at any stage during the painting process. Similarly, if part of a painting becomes too busy and threatens to spoil the impact of the work, I mix up some fairly thick opaque colour and paint this over the area to simplify it. I quite often simplify the sky in this way, to make it a contrastingly quiet area.

below: *Cornish Harbour Cottages*
mixed media on mountboard
35.5 x 58.5 cm (14 x 23 in)
Shapes, colours and textures each play
their part in creating a successful, coherent
composition in which the viewer's attention
is held within the picture area.

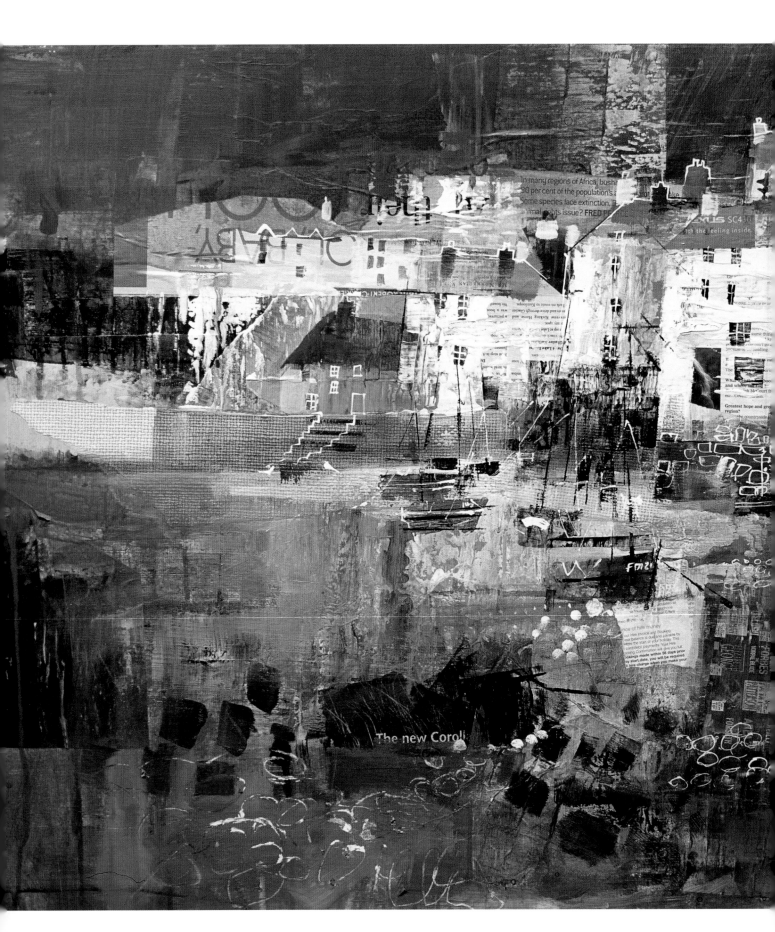

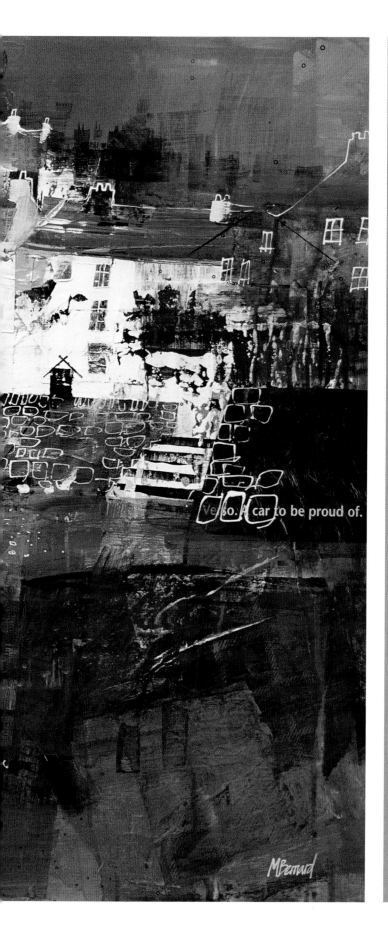

From start to finish

Cawsand, Cornwall

Inspiration

Inspired by shapes, colours and textures, and developed from a location sketch, this painting is typical of the way I like to work. The scene, at Cawsand in Cornwall, had all the elements that most appeal to me: a repetition of shapes, particularly with the rooftops, and thus the potential for a rhythm and pattern effect in the composition; colour that encouraged a limited-palette approach; and, with the different textures of the foreground shore, sea wall, buildings and so on, opportunities to explore exciting surface qualities in the painting.

Technique

On site, I made a line drawing and took some photographs. Then, I worked on the thumbnail sketches to explore ideas for the composition, in which, as you can see, I have used various intersecting verticals and horizontals, creating a repetition of '+' and 'T' shapes. I decided on a limited palette of contrasting cool and warm colours. I did not feel bound to work with the colours as seen, but wanted to make my own interpretation and add to the impact of the painting. I felt that an orange-red sky would suit the mood and form of expression that I had in mind.

As usual, I started with collage to create a broad sense of the composition. Next, I added washes of colour and began to develop the different textures. Most of the underlying texture was created by using white acrylic paint applied with a small lino-printing roller or a length of card. Then, transparent colour glazes were applied over these areas, using a wide, soft varnishing brush. Other textures were added, including a spattered textural effect, using a toothbrush. The final details, the lines of the windows, steps, harbour walls and so on, were drawn with a dip pen and white and black acrylic inks.

left: *Cawsand, Cornwall*
mixed media on MDF
61 x 86 cm (24 x 34 in)

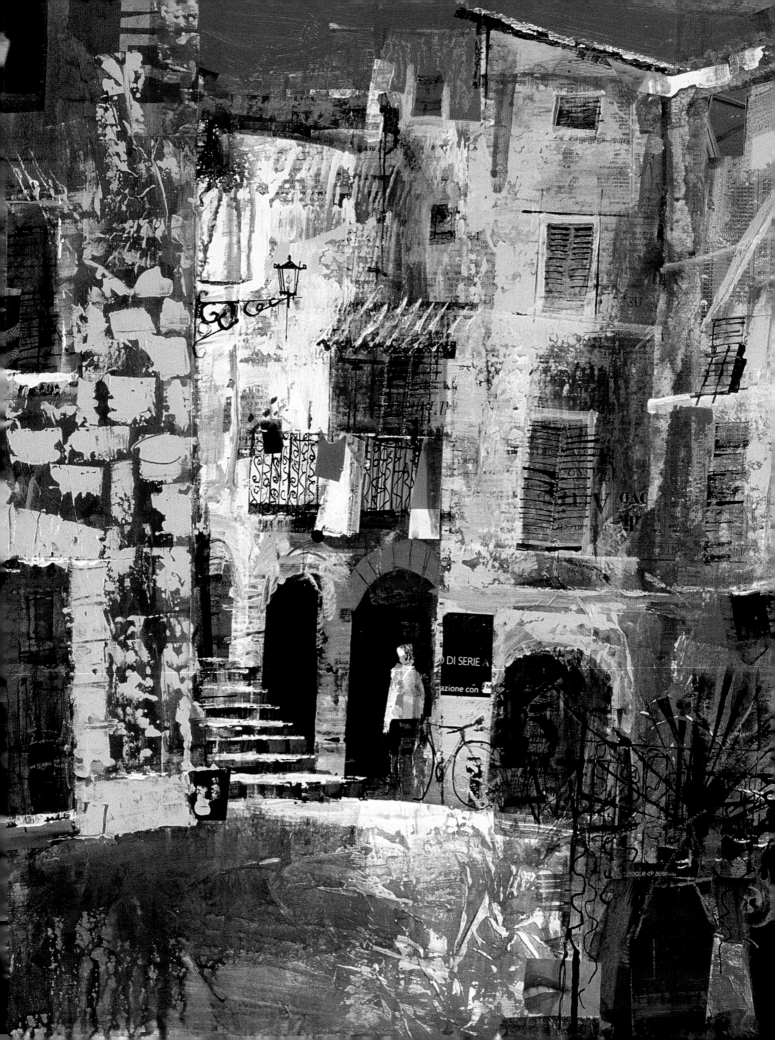

2 Interest and Impact

In my view, the best paintings are more than simply a skilful representation of something that the artist has observed. Instead, they reveal a personal response to the subject matter, and equally, as with style and paint handling, this is expressed in an individual way. Successful paintings have impact. They attract our interest and give us something original and challenging to look at and think about. There are many different ways of doing this, of course: the subject matter itself might be unusual or dramatic; the treatment of formal elements, such as colour and composition, might be very bold and exciting; and there are lots of different approaches possible in the use of brushwork and developing the surface quality of a painting.

Texture is the most distinctive element in my work: it is chiefly through the use of texture that I express what I feel is important about each subject, and at the same time create a painting that has interest and impact. I am thinking of texture right from the start, when I work with collage to block in the initial underlying shapes for the painting. Subsequently, I usually apply white acrylic paint with a lino-printing roller or a length of card, or work with other media to build up different surface effects. My colours are often bold, but limited in range and secondary in importance to the texture. As in the sky area of *Nutcombe Farm* (below), the colour I use is sometimes unrelated to the actual colour in the subject matter, and this will also add to the impact of the painting.

left: *The Cinque Terre, Italy* (detail)
mixed media on MDF
38 x 30.5 cm (15 x 12 in)

below: *Nutcombe Farm*
mixed media on mountboard
53 x 63.5 cm (21 x 25 in)
Although limited in range, my colours are usually bold and imaginative.

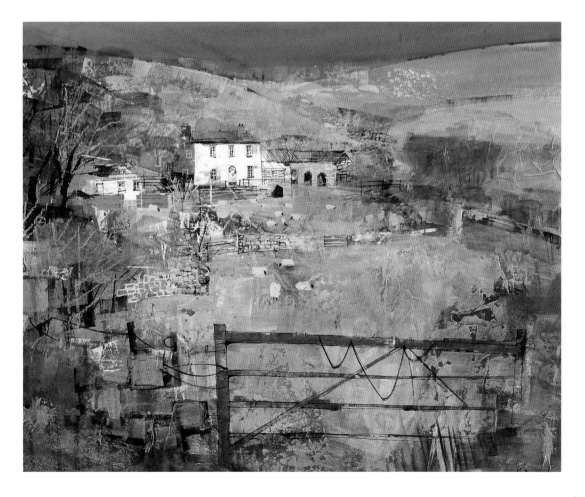

Representation and interpretation

Although my paintings contain strong abstract qualities, they are usually based on real places and scenes that I have observed, sketched and photographed. I want them to maintain that link with reality, but it is also important that they reflect my own thoughts about the subject and the way I like to work. Consequently, in most of my paintings, I am striving to create a balance between the representational and the more subjective and expressive aspects. The different media play a significant part in

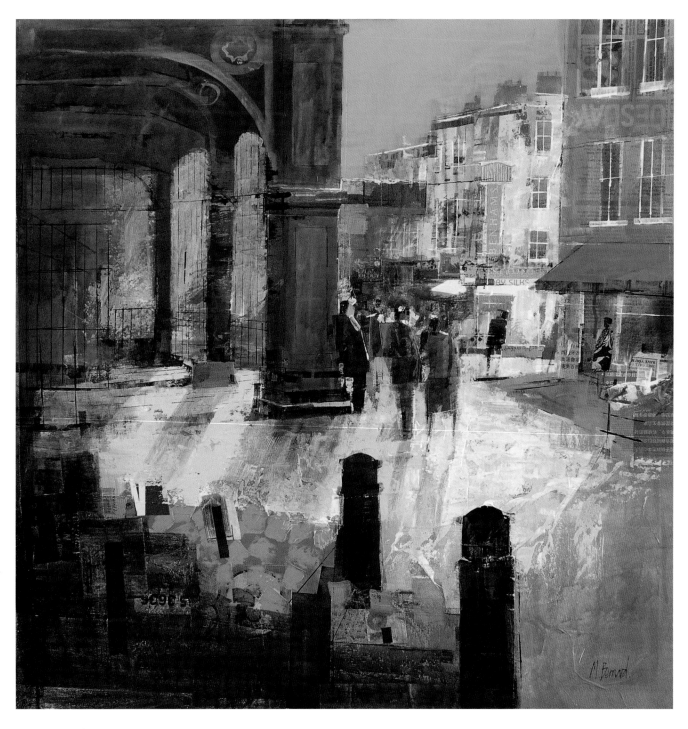

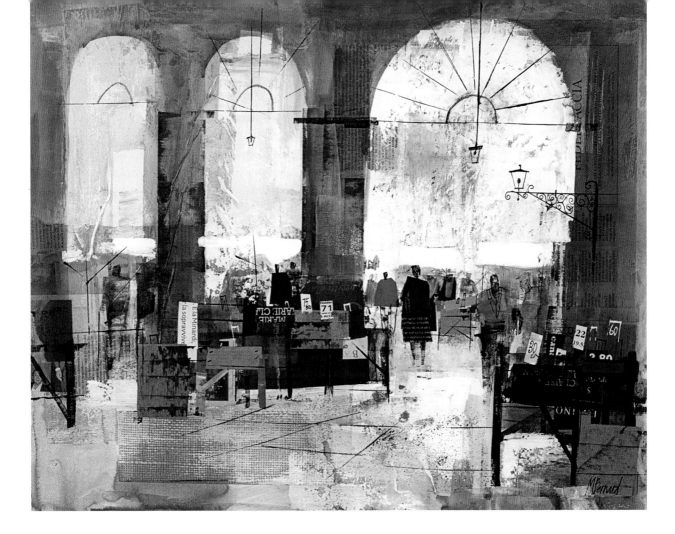

determining how an idea is interpreted. Drawing is a key factor in the way that I develop each painting, and certainly, when I start to define outlines, windows, masts and so on, drawing is the most obvious element in creating the balance between abstraction and reality.

However, I do not follow the conventional approach of making an initial drawing to plot the composition and give me a structure to work from. Instead, the drawing is introduced gradually and generally with some restraint. I start with loose, abstract shapes and effects, working over these with the media and techniques that I feel are the most appropriate for creating the necessary harmony of colour and textural qualities that will make an effective painting.

Starting with observation

I have always relied on direct observation of the subject matter, making sketches and notes on site as the starting point for my paintings. Drawing is an essential skill for every artist; for me, drawing and observation are aspects of the working process that are inextricably linked. In making a drawing, you learn to look, analyse and build up a visual knowledge of things. Equally, the practice of looking and studying different shapes, tones, textures and so on helps you to improve your drawing skills.

When we first start drawing, there is a natural inclination to aim for a result that is as realistic as possible. This is valuable practice, but gradually, with experience, the drawing process can be more focused and selective, particularly if you are making drawings as a reference for paintings. Often, the most important things to consider in a drawing (more so than capturing detail and realism) are qualities such as the spaces between shapes, tonal values, the relative scale of different objects, and the key elements of the composition.

above: *Fruit Market, Sicily*
mixed media on mountboard
51 x 61 cm (20 x 24½ in)
With architectural subjects, particularly, it is important to have good reference material to work from.

You can see how such qualities are relevant to the eventual painting in *Summer Street Scene, Borough Market* (page 38) and *Fruit Market, Sicily* (page 39), for example. In both of these paintings there is an awareness of scale and an interaction of positive and negative shapes. But interestingly, in architectural subjects such as these, it is also essential to have some accurate reference for the buildings – because if the buildings do not look convincing, the painting will lose its credibility. Photographs can be useful for this sort of information.

Contrast and emphasis

One of the dangers of attempting to interpret something exactly as seen is that it will result in a very 'busy' painting, with no strong sense of focus or impact. The most successful paintings have an inherent visual coherence, in that the content and composition work as an interesting, integrated unit, yet at the same time this includes areas of contrast and emphasis. It is usually these areas that most enliven a painting and give it a particular purpose and meaning.

Whatever the subject matter, there must be a certain degree of selection if a painting is to work effectively. Some of the most crucial and influential decisions made for any painting are those concerning which features of the subject matter to include, and which to drastically simplify or perhaps leave out altogether. Moreover, similar decisions have to be made throughout the painting process – you may want to add a little more detail and emphasis to an area, for example, or you may think that something is unnecessary or too distracting and therefore decide to paint it out. When nearing the end of a painting, I quite often simplify areas in this way, or apply a glaze of colour across something to soften its impact.

The process of simplifying and selecting can also apply to other aspects of painting, such as the use of colour. A huge variety of colours can be a distraction and lessen the impact of an idea. Generally, I keep to a very limited range of colours, making my decisions to enhance the quality of the painting rather than suit a literal interpretation of the actual colours found in the subject matter. An advantage of working in mixed media is that I can easily change a colour or block out a shape if it is wrong, using either collage for this or opaque acrylic colour.

Similarly, there is no problem when simplifying the content of a painting. If I decide that certain details or parts of the subject matter are unnecessary, I do not have to worry about what to include instead – I can replace those areas with interesting textures or surface effects worked in mixed media. In fact, working with a limited palette and simplified content helps to create a more unified, harmonious composition. This was my aim in *Stormy Sky, Ireland* (right), in which I have greatly simplified the foreground area and relied on a very limited tonal and colour palette to enhance the impact and mood of the painting.

right: *Stormy Sky, Ireland*
mixed media on mountboard
46 x 63.5 cm (18 x 25 in)
I find that working with a limited palette
and simplified content helps to create a
more unified, harmonious composition.

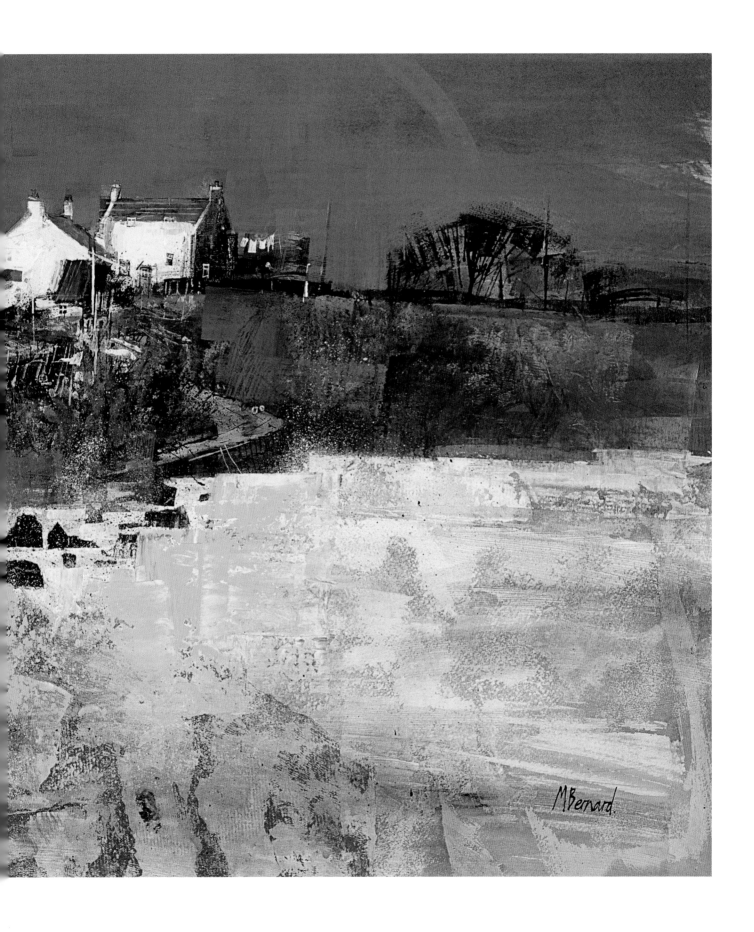

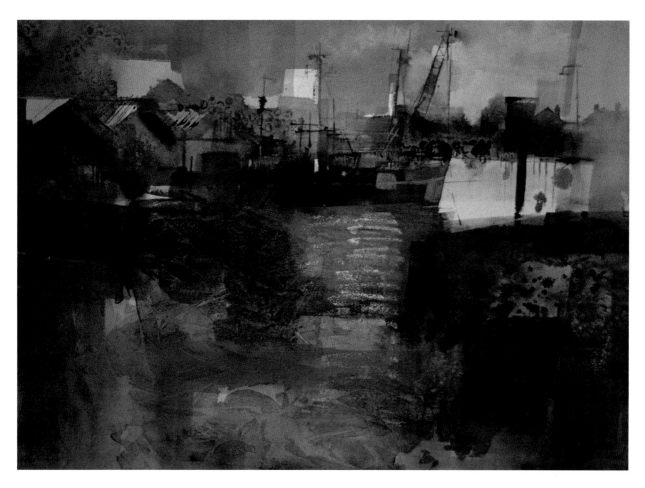

above: *Portsmouth Harbour*
watercolour on Not watercolour paper
56 x 76 cm (22 x 30 in)
Some of my paintings are more abstract
and experimental than others. It is good
to try different subjects and ways of
interpreting them.

Something different

There is great value in being adventurous in the way that you work, and at least occasionally trying something that is more ambitious, different or experimental than normal. Perhaps, as I did, you are keen to make a radical change in your painting style – in which case you may find that working with mixed media is the answer. Every painting is different, of course, and has its own challenges. Certainly for me, mixed media offers the freedom to work in a more expressive, individual way and it encourages exciting, original results. When, in the early part of my career, I painted in a very traditional manner, I found this quite restricting and not nearly as rewarding.

I accept that painting in mixed media involves certain risks, but the fact that there is no set method of working – and in consequence you can exploit chance effects and in a sense 'discover' the painting, rather than make it fit a preconceived idea – is a positive advantage. Now, I deliberately start in a very intuitive way, without letting the subject matter or particular objectives for the painting dictate the working process. Once I had overcome the need for outlines and an initial defined composition, the painting process became much more inspiring and successful.

The usual practice for starting a painting – by working on a white sheet of paper and making a drawing – can be very inhibiting. However, especially if someone has taken a lot of trouble to create accurate outlines and a well-balanced composition, there can be a reluctance to make changes: the outlines become defining points, boundaries that must not be crossed. Thus, the way the painting will be developed is governed from the very beginning, and there is little scope to alter it. Whereas, by starting with a few bold collage shapes, as I do now, the options remain open.

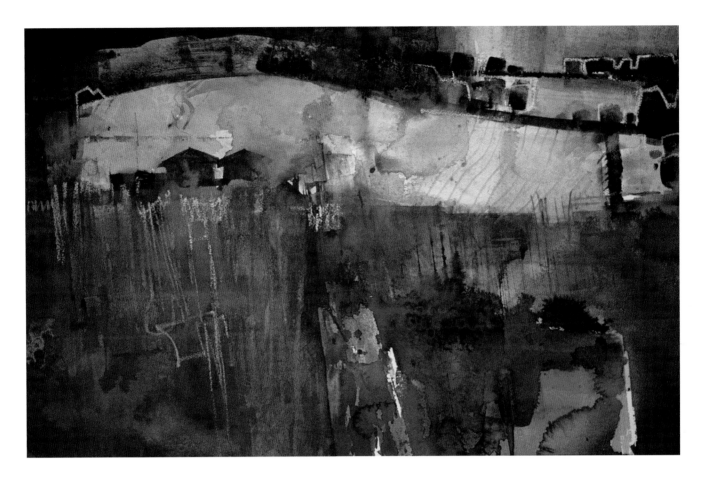

When I taught art, I used to encourage my students to find an alternative to the accepted notion that you must begin with a drawing, and I particularly encouraged them to think about some way of dealing with the white surface of the paper, again because it can be so inhibiting. Always, my advice was to block out the white surface as soon as possible, perhaps using wet-into-wet washes or collage. The collage might begin to suggest some of the main areas and divisions of the painting or, if washes were used, these could relate to a certain mood or atmosphere. Usually, to ensure the control and coherence of the painting, I advised restraint in the choice of colours – perhaps just two or three analogous or harmonious colours (those next to each other, or groups of colours in the same section of the colour wheel); see also page 90.

Mostly, as I have said, I am working with reference to a particular place or idea, but now and again I start without any drawing or subject in mind. *Hampshire Landscape* (above) is an example of this approach. It was painted in watercolour, which allowed me to start in a totally experimental way, creating different textures by, for example, pressing clingfilm and bubble wrap into the wet paint. Some of these chance effects suggested trees to me, and so I began to develop the painting as a landscape subject. In fact, although the majority of my paintings are developed from location drawings and photographs, they always involve a good degree of imagination and invention.

above: *Hampshire Landscape*
watercolour on Not watercolour paper
51 x 76 cm (20 x 30 in)
As here, I occasionally work in an entirely experimental way, without reference to any drawings or subject matter, relying on chance effects to suggest an idea from which to develop the painting.

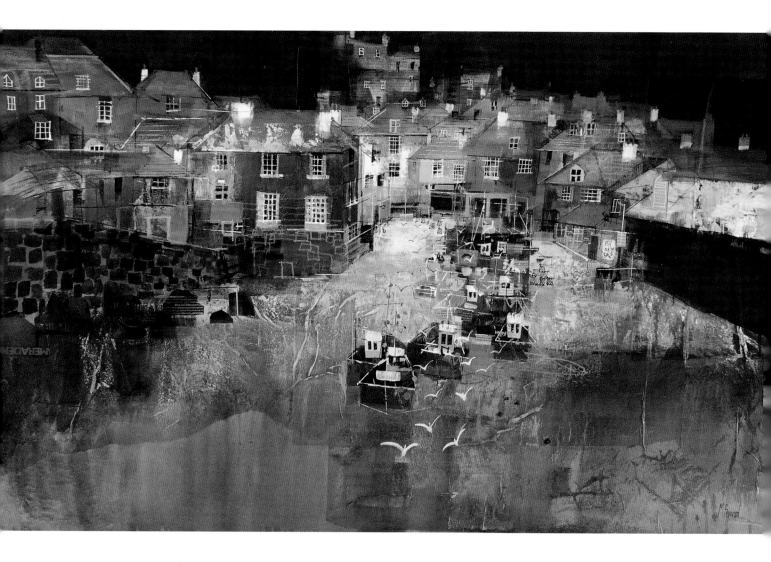

Abstract qualities

It might only be a small area of broken colour or impasto, but there are abstract qualities in most paintings, even those that aim for a high degree of realism. Other than abstract expressionism, op art and similar pure abstract forms of painting, essentially it is the degree of simplification, and/or the way that the paint surface is handled, that gives a painting an abstract quality.

There is never a conscious plan to include abstract elements in my paintings: they develop by virtue of the fact that I like to work with a limited palette, simplified subject matter, and a variety of textural effects. Nevertheless, I like to exploit the interest and contrast that areas of realism and the purely textural (and consequently more abstract) passages create in a painting.

Lost and found

Many artists begin with an underpainting which, in its simplicity of colour and shape, looks fairly abstract. As I have explained, I prefer a working process that allows plenty of freedom, particularly in the initial stages of a painting. I also like the freedom to respond to chance effects and ideas as a painting develops, and if necessary make changes. At first, as I did for *Breakfast* (right), I will usually apply

above: *Port Isaac Harbour*
mixed media on canvas
76 x 122 cm (30 x 48 in)
Most paintings include abstract qualities – it might simply be an area of textural brushwork – even when they set out to be essentially representational.

areas of collage or colour with no particular reference to the drawing and photographs that I am working from. Consequently, at this stage the painting has no clear sense of direction. I have deliberately avoided making any firm statement about the image, deliberately following a process in which I lose the image and then have the challenge of finding it through the mixed-media techniques that I use to develop the painting.

This process of 'lost and found' continues throughout the development of the painting. I might decide to emphasize or define a certain object in one part of the painting, or perhaps subdue something in another area by partially painting over it or adding a transparent glaze across it. And similarly, to prevent the work from becoming too fussy and controlled, I generally use very large brushes, pieces of card or lino-printing rollers for applying the colours. Note the broad treatment of the background area in *Breakfast* (below), for example, for which most of the colour was applied with a 7.5 cm (3 in) flat brush, working with bold vertical and horizontal brushstrokes.

This painting began with collage and then the blocks of blue and blue/purple acrylic ink, so that at first it had a very abstract quality. Then I began to 'find' the different objects, often developing shapes that were already partially suggested by the initial areas of collage and brushmarks – by adding a spout and slightly modifying an area to make a teapot, for example, or by painting in the negative, surrounding space and so forming the shape of a plate. At the same time, I consider the surface pattern of the painting – in *Breakfast*, using squares and rectangles throughout the design, made with paint, collage and oil pastel. The overall sense of a painting is always important, I think: the background as well as the objects and areas that are more recognizable.

left: *Breakfast*
mixed media on mountboard
49 x 57 cm (19½ x 23½ in)
Often I include sections in my paintings in which the paint is handled in a totally free, expressive manner and perhaps is applied with a roller or very wide brush.

Aims and objectives

As for *Harbour Steps, Lyme Regis* (right), I usually work with a specific event or location in mind, aiming to capture something of its character and activity. Often, in creating a sense of place, and representing its particular mood and atmosphere, light is an important factor. However, in general I aim for a quality of light that radiates from the painting and adds to its drama, rather than feeling obliged to copy the lighting that I remember from the location trip and which is shown in the reference photographs.

Paintings should be dynamic and attract attention, even if they are not to everyone's liking. Successful paintings will rely, to a certain extent, on preparation and planning, but this has to be carefully judged. Without any real focus, the work will invariably lack impact, while on the other hand, too much planning can stifle the eventual result. As with many aspects of painting, success lies in achieving the right balance between freedom and control.

right: *Harbour Steps, Lyme Regis*
pencil drawing on cartridge paper
57 x 78.5 cm (22½ x 31 in)
For my location drawings, I normally work in line and tone rather than in colour. This is because I prefer to choose my own colour palette for the subject, uninfluenced by the colours that are actually there.

below: *Irish Coastal Lane*
mixed media on mountboard
43 x 51 cm (17 x 20 in)
Whatever the subject matter and materials and techniques used, it is very important to get the right balance between freedom and control.

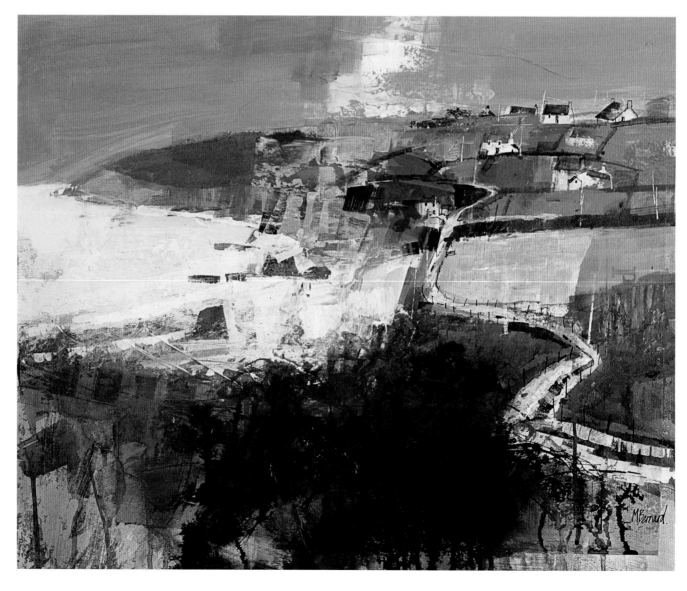

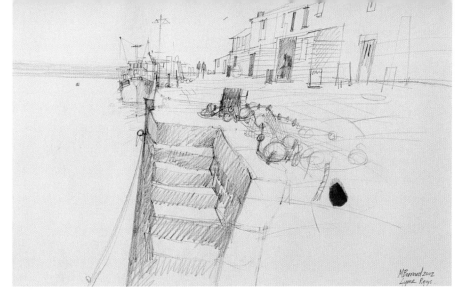

below: *Harbour Steps, Lyme Regis*
mixed media on mountboard
46 x 46 cm (18 x 18 in)
In comparison with the original drawing
(left), you can see that I have changed the
composition dramatically and decided to
work with a limited palette of colours.

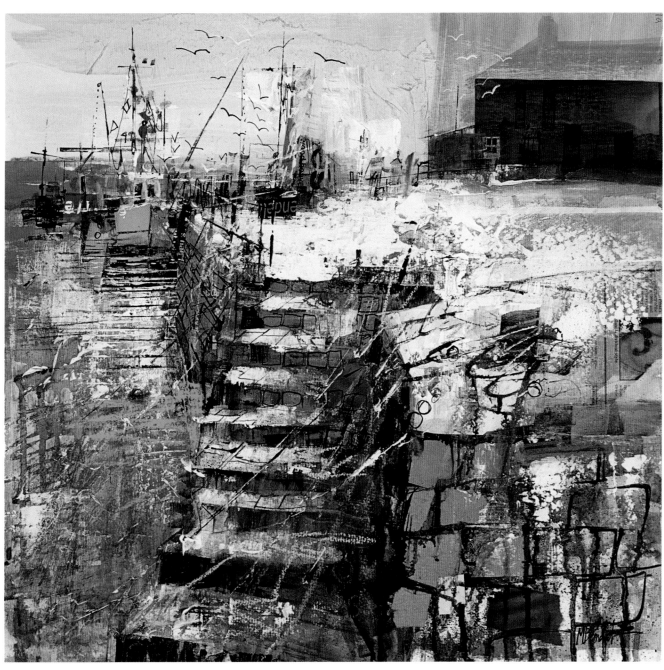

Preparation

For me, the essential factors to consider before starting a painting are composition, colour palette and the scale and format of the work. I make a sequence of very small, simple compositional sketches to help with these decisions. In the sketches, which use the original location drawings and photographs as a starting point, I experiment with the composition, as well as test out different shapes for the painting – I might try cropping the image or adding more to the foreground, and so on. Often, it is a matter of trial and error to see what will work and, by so doing, arrive at an effective design and shape for the painting.

I prefer to work on a large scale, but the decision about size is mainly determined by the subject matter. Panoramic harbour scenes, which are one of my favourite subjects, are ideal for the more expressive approach that is possible with large-scale work. Sometimes I try out a subject on a small board and subsequently paint it again on a much larger scale. In contrast, there are times when I decide to crop the actual painting – to enliven the composition by cutting a section from the board. Some subjects suit a square format which, as demonstrated in *Rainy Night Out, Leicester Square* (below), tends to place more emphasis on the vertical and horizontal divisions, as well as the abstract qualities within the composition.

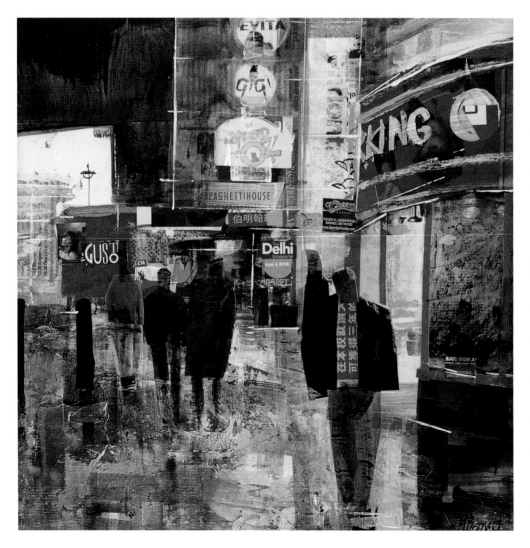

left: *Rainy Night Out, Leicester Square*
mixed media on mountboard
33 x 33 cm (13 x 13 in)
The scale of a painting is mainly determined by the subject matter. I prefer to work on a large scale but sometimes, as here, a smaller size will be more appropriate in order to create the greatest impact.

above right: *Rain in Rome*
mixed media on mountboard
49.5 x 68.5 cm (19½ x 27 in)
In my use of colour particularly, I rely a great deal on intuition and making a subjective response to a painting.

far right: *Mousehole Harbour*
mixed media on mountboard
38 x 38 cm (15 x 15 in)
I find that starting in a very free, relaxed way injects a sense of spontaneity and originality, which carries right through to the finished painting.

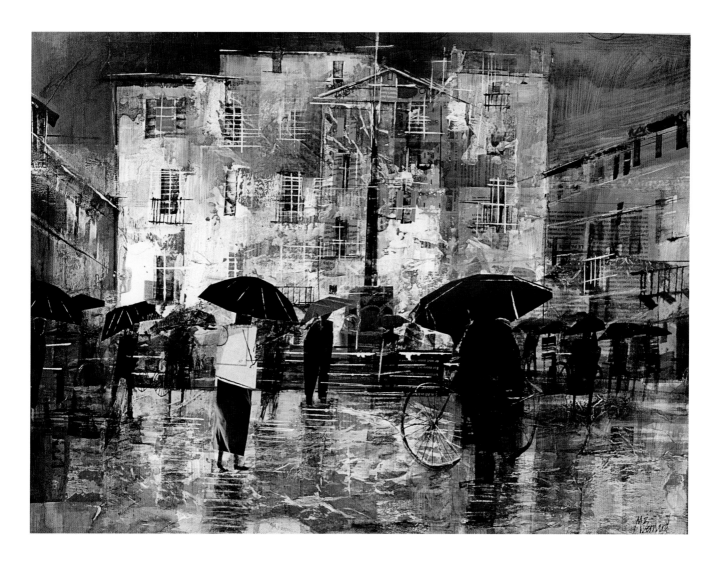

Intuition and feeling

Obviously, experience and sound working practice play their part in my approach to painting, but equally I rely a great deal on intuition and making a subjective response to developments as they happen. This is particularly so at the start of a painting, when essentially there is very little reason or deliberation involved in the shapes and colours that I am using. Mostly at this stage I am allowing the paint complete freedom, and I quite like the idea that it will produce a state of chaos, out of which I then have to find some kind of order.

But there is no pressure at this early stage: I cannot actually spoil the painting. Instead, I am free to enjoy working intuitively and expressively, with big brushes and bold, spontaneous blocks of colour. For me, this initial freedom and relaxed way of working inject a spirit and strength into the painting that carry right through to the finish. Later, if I begin to lose the sense of spontaneity, or the various elements of the painting are not working together as they should be, I might once again apply some very broad areas of colour or collage to help revive the energy and impact of the work.

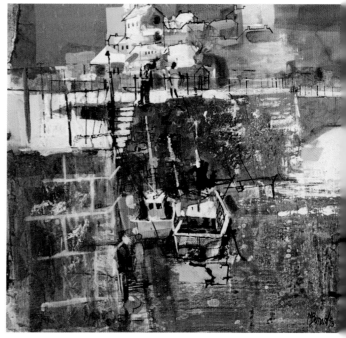

Evaluation

Experience, confidence and intuition all play a very important part in creating successful, interesting paintings. It helps to believe in your intuition, I think, because often the first decision is the right one – whereas questioning decisions can sometimes undermine one's confidence. However, there are times when it is worth standing back from a painting to take a more critical view of its development up to that point.

The different techniques and media I use mean that inevitably, at various stages, paintings have to be put aside to dry, and consequently I have quite a few paintings in progress at the same time. The advantage of this is that one idea can inform another, and also, after a painting's 'rest', I get to see it afresh, and it is this sense of immediacy – in being able to reappraise the work at a glance – that I find most useful.

Whilst you are working on a painting, and therefore are totally involved with it, you become very aware of every mark and detail. However, after leaving it for a time, and then seeing it again, the first response is always the overall sense of the painting, its coherence and general impact, and this is what counts most. In a similar way, sometimes when paintings come back from exhibitions, and I have not seen them for a while, I notice something that is not quite right – something that was not apparent when I was busy working on the painting – and I make the necessary alteration.

If you lack confidence in your own assessment of your work – and of course there are the dangers of complacency or alternatively being too self-critical – you could invite someone else to offer an opinion. Choose someone whose judgement and advice you value. And in conjunction with this, looking at other artists' work can be a very helpful source of ideas and inspiration. Seeing a technique used effectively by another artist can sometimes give you the confidence to try a similar approach in your own paintings.

left: *Moored Fishing Boat and Fishermen's Cottages*
mixed media on mountboard
56 x 71 cm (22 x 28 in)
At various stages, paintings must be left to dry. The advantage of this is that when you return to a painting, you see it afresh and so are able to reappraise the work and decide on the next step.

From start to finish

Glimpse of Southwark Cathedral

Inspiration

With its essential architectural theme, this subject encouraged a more representational approach than I would normally adopt, although even here I have used a fair amount of invention. I started by making a drawing on site and taking some photographs. The quality that most impressed me about the subject was the delicacy of the ironwork in the façade of the main market building when seen against the bulk of the structure behind and the cathedral tower. However, in reality, a large part of the market façade was obscured by the buildings on the left, and so I have radically altered the viewpoint and perspective in my interpretation of the scene.

Technique

As always, the surface quality of the painting was a key consideration, and I used a variety of materials and techniques to capture the effects that I felt were important, especially the impact of light. Working with white acrylic paint, I decided to emphasize the sunlit tower and balance this effect with an area of reflected light in the foreground. The structure of the painting is based on strong verticals and horizontals, although in places contrasting the straight lines with various arched shapes.

In addition to exploiting light as a linking device in the composition, I have used groups of shapes, such as the figures, and a restricted colour palette. The different blue tones draw the eye around the painting and at the same time create a sense of unity, just interrupted here and there by the red and orange shapes, which introduce added points of interest.

right: *Glimpse of Southwark Cathedral*
mixed media on canvas
61 x 76 cm (24 x 30 in)

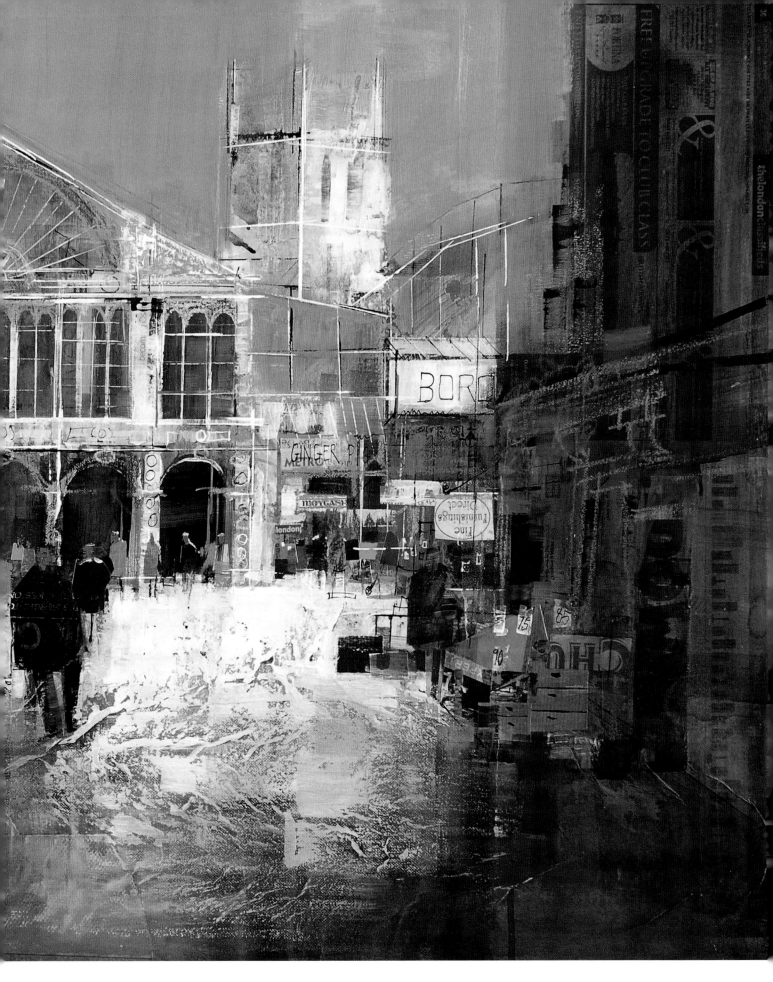

3 Complementary Media

Working with mixed media has many advantages, especially for those artists who value personality and expression in their paintings. Being able to utilize the contrasting qualities of different media enhances the potential for creating interesting colour and textural effects and producing paintings that are original and exciting. Because texture is always a vital element in my work, I enjoy the fact that a mixed-media approach allows me to interpret the various surface qualities in the subject matter in a more direct, tactile and successful way.

Unfortunately, 'mixed media' is a term that is sometimes misunderstood. For some artists there is a perception that, in adopting this approach, it is far more difficult to create successful results. They fear that working with a combination of, for example, wet-into-wet techniques, drawing and collage, will involve tricky aesthetic and technical challenges. However, this has not been my experience, and I would always encourage artists to try working in mixed media, although naturally, as with any form of painting, it can take time to develop the necessary confidence and skills.

Essentially, there are two approaches: either to use water-based media, perhaps in conjunction with collage and various associated techniques, or to keep to oil-based media. I usually work with acrylic paint, acrylic inks, collage and oil pastel. Most artists have some experience of different media, in addition to the one that they specialize in, and this makes a good starting point for experimenting with combined techniques and media. Initially, my advice is to try techniques such as pen and wash – working with broad areas of colour for the main shapes, with diluted ink, watercolour, gouache or acrylic paint, and using a pencil or pen for adding lines, details and textures. The best way to gain a knowledge of the strengths and characteristics of different media is by experimenting – allowing yourself the time to 'play' with each medium without feeling under pressure to create specific results.

left: *End of the Day, the Red Fishing Boat*
mixed media on hot-pressed watercolour paper
58.5 x 53 cm (23 x 21 in)

Collage in action

The way that I normally develop a painting, starting with the initial foundation work in collage, is demonstrated in the five step-by-step illustrations for *Polperro Harbour* (right).

In Stage 1, you can see how I have built a collage from pieces of paper to establish a sense of the basic design for the painting. There is a dark shape on the left, which is the first indication of the foreground sea wall; similarly, an orange/brown rectangular piece of paper, centre right, creates a foundation texture for another section of the harbour wall. Additionally, the newspaper at the top hints at some fishermen's cottages, while some wrinkled tissue paper below suggests where the water is going to be.

This might imply that I am only thinking about the subject matter in literal terms. However, I am also considering the way that various shapes interrelate and begin to create interest and balance within the design. For instance, you will see that I have placed some tissue-paper shapes at the top to balance the ones in the foreground. Equally, I am thinking of the textures and how these could be used to advantage later on.

Next, as in Stage 2, I sometimes develop the collage further, before starting to apply the two main colours that I have chosen for the subject. I decided to use a blue and a golden sand colour for this painting, working as usual with acrylic inks and applying them with a soft-haired 5 cm (2 in) varnishing brush. The collage must be dry before starting on this stage, for which I first wet the paper by spraying it with water. With the painting held vertically at an easel, I apply the colours quite randomly, allowing them to run and create haphazard effects.

With the entire painting surface now covered in some way, either with collage or colour, I begin to think more particularly about textures. For those areas in which a rich textural quality will be useful, I use white acrylic paint, which is applied quite freely with a lino-printing roller, as shown in Stage 3. Again, I aim to create a sense of unity in the painting by repeating the texture in different areas, although avoiding those passages of the initial blue or golden sand colour which I estimate will relate to specific parts of the subject matter. As well as adding texture, the white acrylic paint imparts a luminosity to the painting later on, when coloured glazes made from diluted acrylic inks are applied over it.

During the next stage, with a fresh look at the location drawing, and where appropriate exploiting the divisions, marks and surface effects that are now part of the painting, I start to resolve the essential elements. As you can see in Stage 4, I have now defined the main house, using white acrylic paint, and with black acrylic ink offset from the edge of a piece of card, I am putting in some fencing posts. The challenge is to balance areas that give meaning and definition with those that are left as textural, abstract qualities.

Finally, as shown in Stage 5, I draw with a dip pen and some black or brown acrylic ink to add any further outlines and details that I think are necessary.

stage 1: *Polperro Harbour*
With reference to the subject matter, the foundation work is done in collage.

stage 2: *Polperro Harbour*
After further work with collage, the initial colours are added, using a varnishing brush.

stage 3: *Polperro Harbour*
Introducing texture: white acrylic paint is applied with a lino-printing roller.

stage 4: *Polperro Harbour*
Working with white acrylic ink, offset from the edge of a piece of card, to add structure and definition to the painting.

stage 5: *Polperro Harbour*
mixed media on hot-pressed watercolour paper
48 x 56 cm (19 x 26 in)
Drawing with a dip pen.

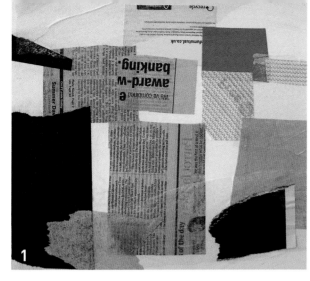

1

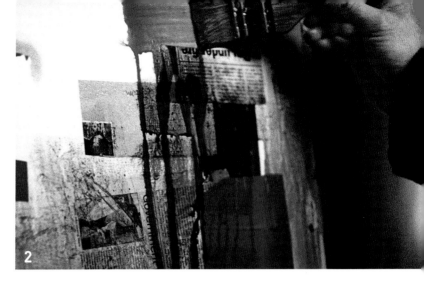

2

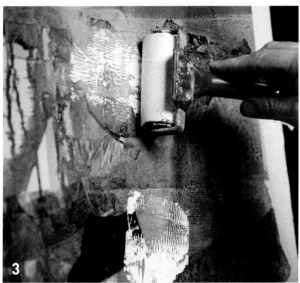

3

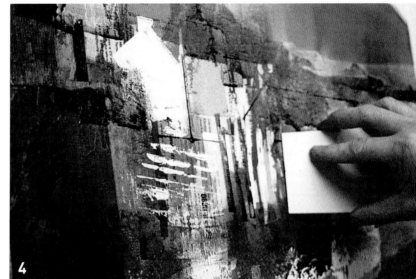

4

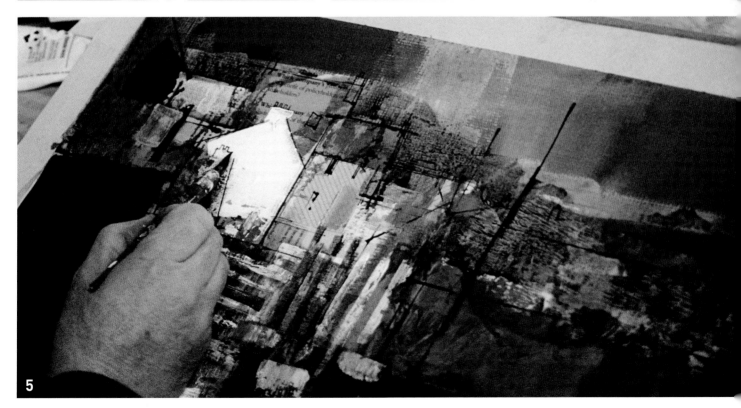

5

Paints

Paint is a versatile medium. For example, you can use it straight from the tube, to create expressive textural effects, or dilute it to produce subtle washes and transparent glazes of colour; between these extremes, numerous variations in its consistency and handling properties are possible. Additionally, you can exploit the opaque or transparent nature of certain colours, or the fact that some colours are more intense than others or have a greater staining power, and so on.

Again, much depends on experience and in getting to know the particular characteristics, strengths and limitations of each type of paint and the colours in its range. Undoubtedly, paint is an essential medium in the early stages of a work and, whether applied with brushes, painting knives, fingers, lengths of card or whatever, it offers tremendous scope for exciting, sensitive colours and textural effects throughout the development of a mixed-media image.

Acrylic paint

Acrylic paint is compatible with most other paints and drawing media. It is an ideal medium for mixed-media work in that it is water-soluble when wet but permanent when dry, easy to use, and it will also act as an adhesive when torn or cut collage shapes are pressed into its wet surface. Additionally, it has the advantage that there is no particular working process that must be followed – unlike when using watercolour, for example, when it is necessary to work from light to dark. With acrylic colours, you can add lights or darks at any point during the painting process.

Also, mixing and thinning the paint is very straightforward: either add water or use one of the various acrylic mediums that are available. These include gloss and matt glazing medium, flow improver (which increases the transparency of colours and the ease with which they can be brushed on), and texture gel (which thickens the paint for impasto effects). There is a wide choice of colours; most are opaque.

These different factors and characteristics offer immense scope for developing a personal style of work, although it is always wise, I think, not to overplay techniques and effects. I sometimes use the conventional range of acrylic colours, but generally I keep to a restricted palette and quite often I use just two colours – unbleached titanium (creamy white) and parchment (off-white), both from the Liquitex heavy body professional artist's colours. Essentially, I only use the acrylic colours to create underlying textures in a painting. For the actual colours I mostly rely on acrylic inks, often applied as glazes, and areas of collage. When I want to create a more opaque, textural colour, I mix acrylic ink with white acrylic paint.

right: *Marina Grande, Sorrento*
acrylic and mixed media on MDF
86.5 x 86.5 cm (34 x 34 in)
By exploiting its consistency and handling
possibilities, acrylic paint will allow many
different expressive textural effects.

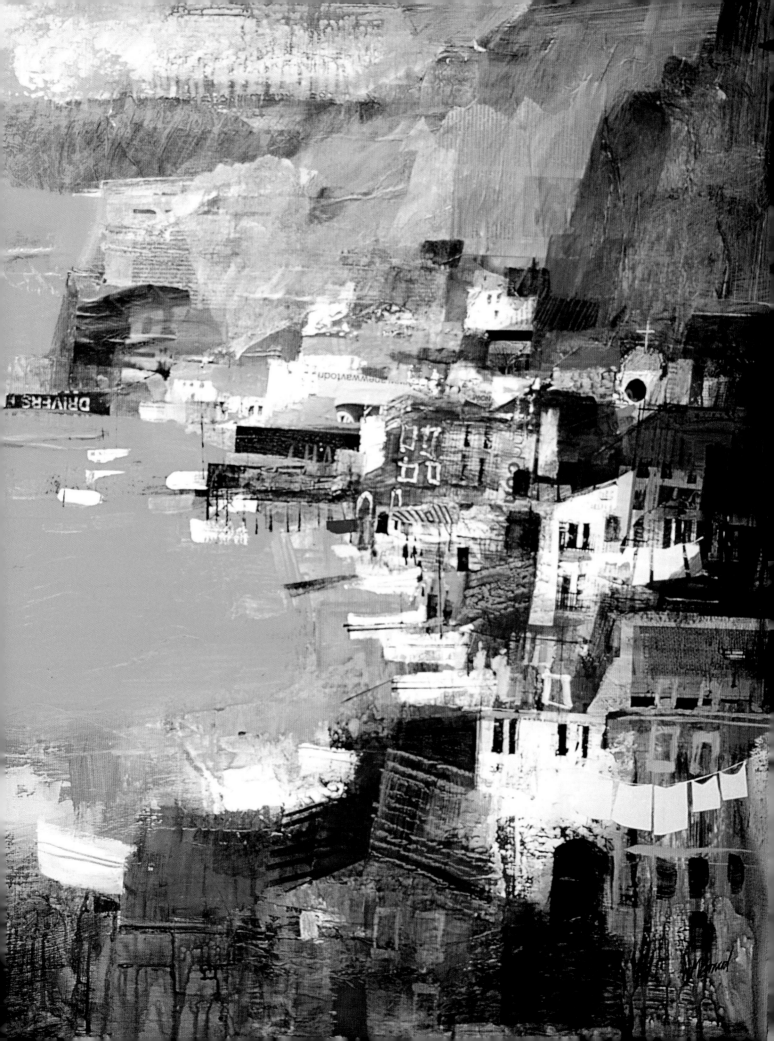

Kentish Harbour (below) is an example of a painting in which I have kept mainly to acrylic colours. For such paintings, I generally start in the usual way, with collage, and I might also introduce elements of collage later on. But essentially, I want the colours to be solid and intense, and this is why I choose acrylics. For example, the yellow boat in *Kentish Harbour* could have been painted using a yellow glaze (made from acrylic ink), applied over a white acrylic base – which is how I would normally work. But this would not have given the same sense of solidity. In contrast, in *Fruit and Veg Shop, Orvieto* (right), I have worked in a far more restricted way with the acrylic colours, relying mainly on the parchment white acrylic to create texture and simplify areas where necessary, particularly in the top right-hand section of the painting.

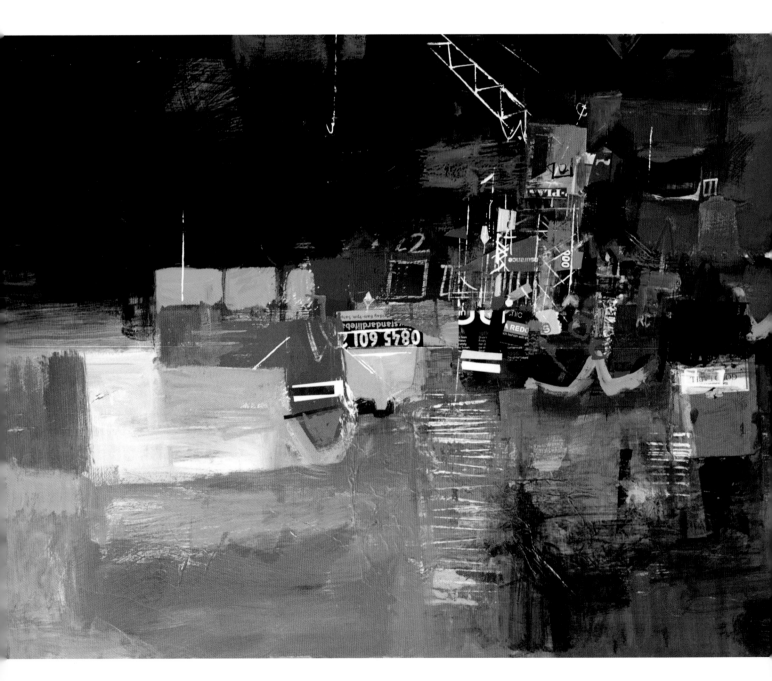

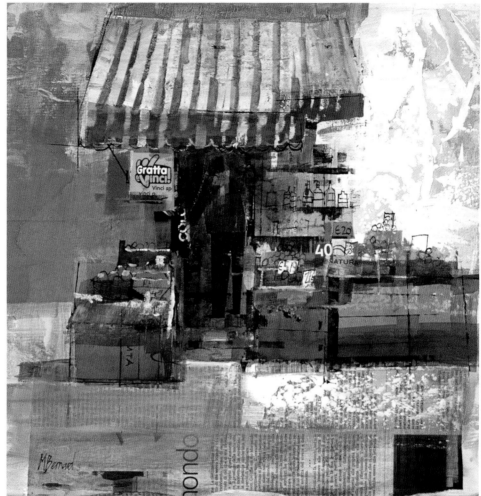

above: *Fruit and Veg Shop, Orvieto*
mixed media on MDF
35.5 x 35.5 cm (14 x 14 in)
I often use parchment white acrylic
colour to block out and simplify areas.

left: *Kentish Harbour*
collage and acrylic on MDF
61 x 101.5 cm (24 x 40 in)
Acrylic paint is ideal for a subject such as this,
in which I want the colours to be solid and intense.

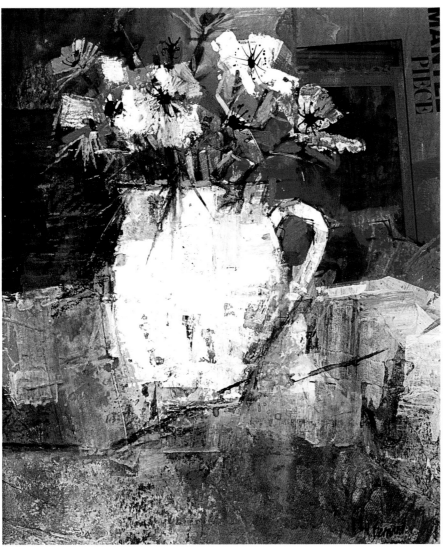

above: *Anemones*
mixed media on mountboard
35.5 x 30.5 cm (14 x 12 in)
Acrylic paint is particularly good for mixed-
media work. It combines well with collage,
inks, pastels and other media, with the
added advantage that it dries quickly.

right: *Old Fishing Boat, Mevagissey*
mixed media on mountboard
28 x 37 cm (11 x 14½ in)
When required, you can apply acrylic colour in
quite a controlled manner, as in this subject.

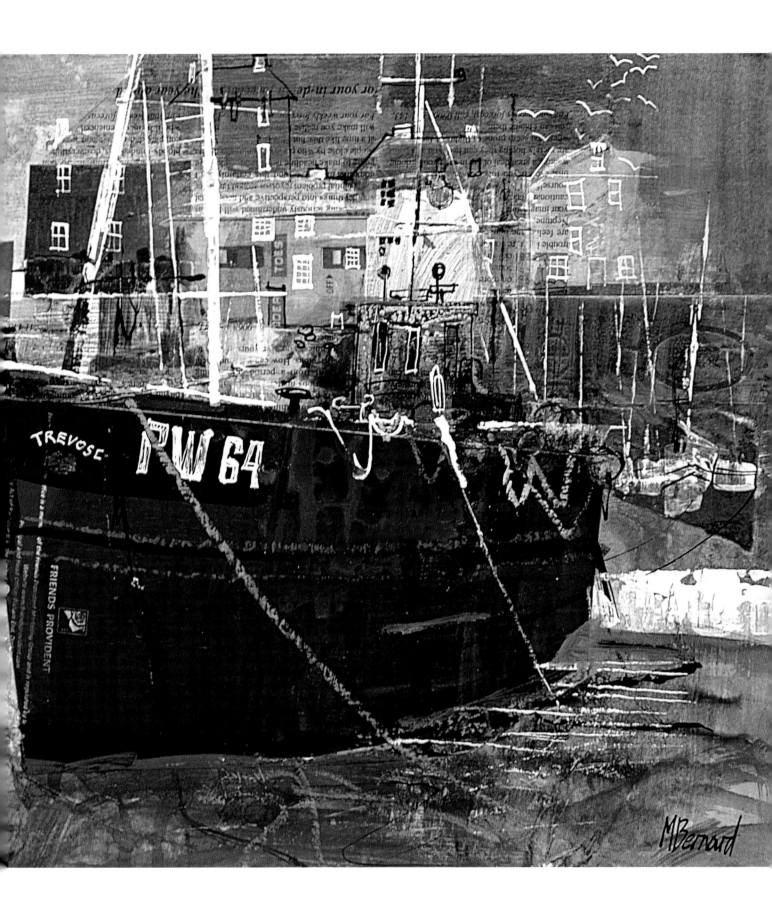

Control and happy accidents

There are numerous decisions to make at every stage in the painting process. Some of the most important of these relate to the colours, textures and other aspects of the painting that are worth preserving, and those that need modifying or resolving in some way. In the early stages, I deliberately encourage different surface qualities, random runs of paint and similar effects that subsequently might add interest and impact to the painting. But later, as I start to work with more control and concern for a particular mood and content, most of the initial colours and textures will be covered over. Throughout the painting, I am seeking the right balance between the more deliberate effects and those that happen by chance.

This combination, of controlled and fortuitous effects, is evident in *Venetian Backwater* (below), for example. Here, there is some very careful drawing with white acrylic paint and ink to suggest some of the architectural detail, while in contrast, in

below: *Venetian Backwater*
mixed media on MDF
40.5 x 51 cm (16 x 20 in)
Often, I make use of some of the initial 'happy accidents' in the paint surface – the runs, drips and paint textures – to help enhance the subsequent development as I begin to resolve areas such as the foreground water in this painting.

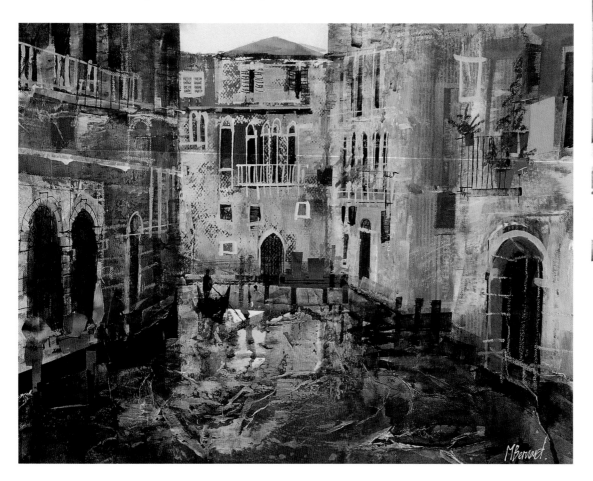

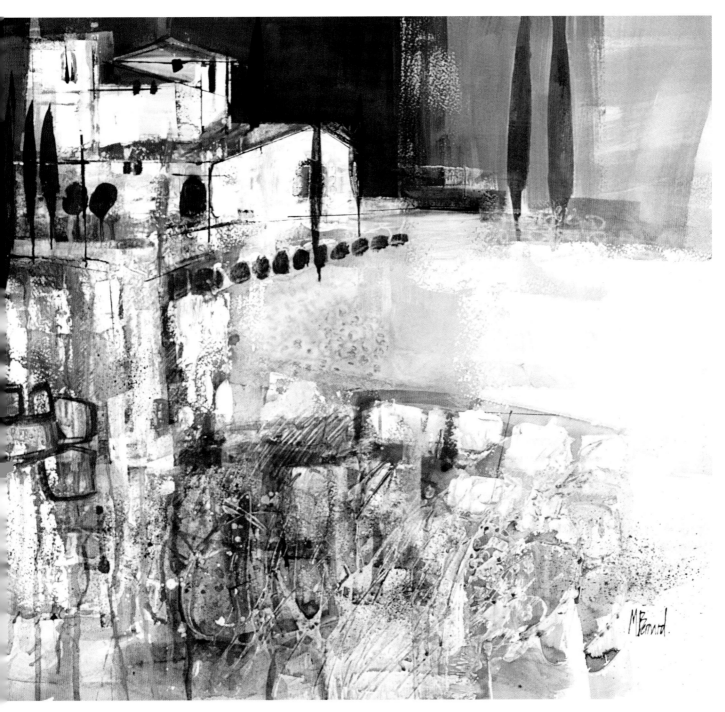

above: *Tuscan Villa*
mixed media on Not watercolour paper
48 x 66 cm (19 x 26 in)
In this example, I have further exploited
the chance effects resulting from the
first freely applied areas of colour.

the foreground, to help capture the feeling of water and reflections, I have made use of effects left from the initial foundation work. These include textural washes and drips of paint, creased tissue paper and tinfoil.

Again, in *Port Isaac* (below), there is quite a lot of drawing with white acrylic ink, although in this painting many of the lines and colours are softer and slightly diffused. To create this quality, I periodically used a plant sprayer to apply a fine mist of water over the painting. And for *Spanish Farm* (right), I used oil pastels to draw the foreground plants and grasses, before applying colour washes over this area. This combination gives an interesting resist-textured effect.

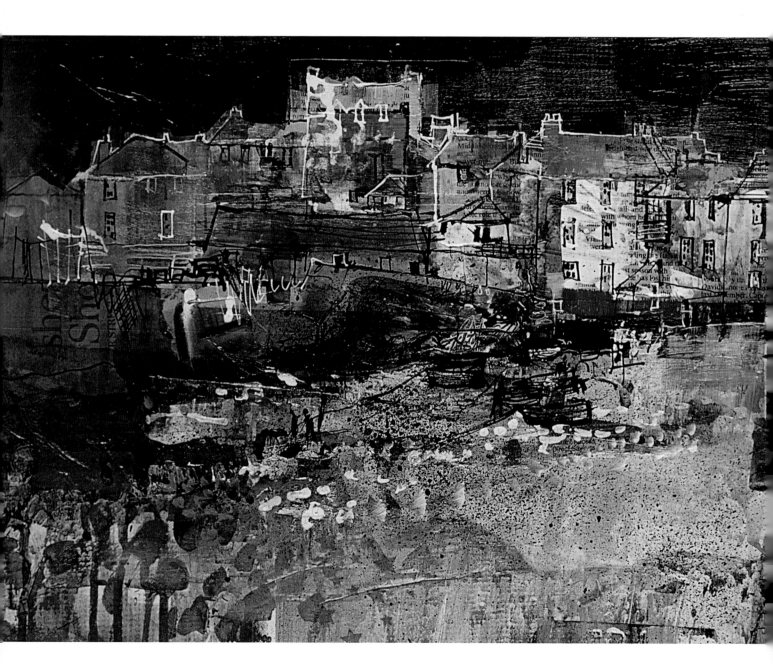

right: *Spanish Farm*
oil pastel with mixed media on mountboard
40.5 x 40.5 cm (16 x 16 in)
For this subject, the lively foreground textural
effect was created by applying colour washes
over a drawing made with oil pastels.

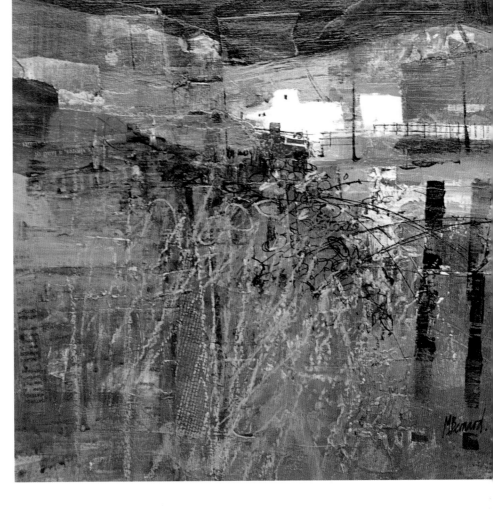

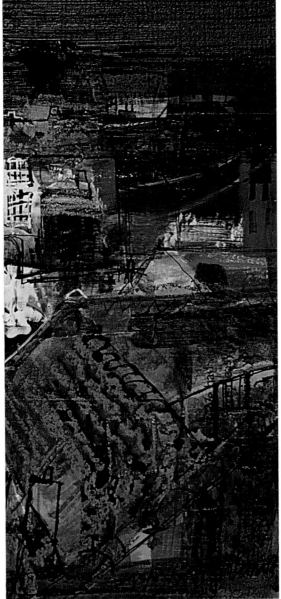

left: *Port Isaac*
mixed media on mountboard
38 x 56 cm (15 x 22 in)
For the more graphic approach here, I worked
with a dip pen and white and black acrylic inks,
which I sprayed periodically with a fine mist of
water to produce a soft, atmospheric effect.

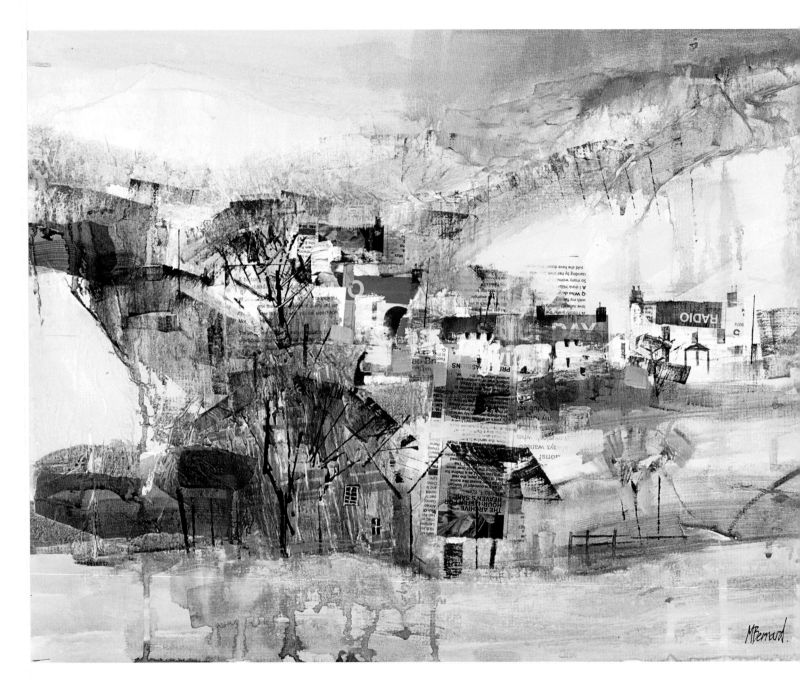

above: *Branscombe Landscape*
mixed media on mountboard
40.5 x 53 cm (16 x 21 in)
I like to add details by 'drawing' with the
edge of a small piece of card dipped in
acrylic ink. This gives some interesting
effects and also prevents the work from
becoming too fussy. The tree shapes in this
painting were drawn in this way.

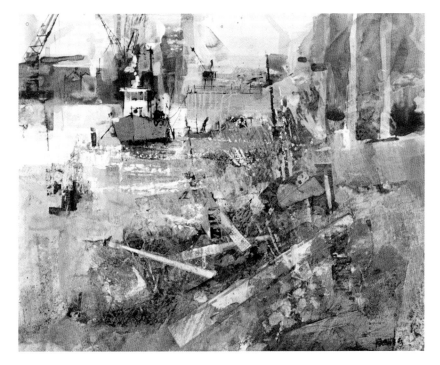

left: *Shamrock Quay, Southampton*
mixed media on mountboard
33 x 38 cm (13 x 15 in)
Acrylic inks can be quite intense if used
directly from the bottle, but will give much
more subtle tones when diluted with water.

below: *Sicilian Harbour*
mixed media on mountboard
43 x 56 cm (17 x 22 in)
Used as a glaze, acrylic ink will help to
unify areas, although at the same time
allow some of the underlying textures
and effects to show through and add
interest to the painting.

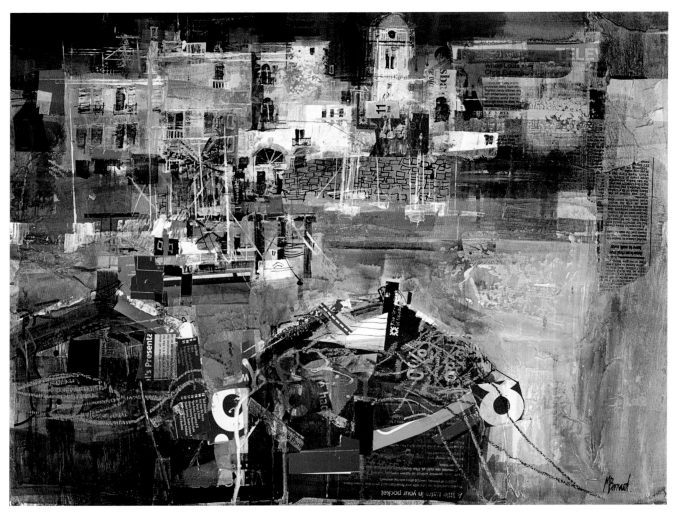

Visual interest and coherence

To be successful, paintings need a strong visual appeal generated from their use of colour and other formal elements, and equally they must work effectively in terms of design, showing an inherent unity and coherence. Naturally, when using a wide variety of media, it can be more difficult to create a painting that works as a whole, which makes it all the more important to consider the consequences of each inclusion and development, so that every aspect has exactly the right significance in relation to the rest. For me, the first priority is for the visual sense of the painting – to ensure that it does not look disjointed, although inevitably this is linked to the fundamental design of the work.

There are several techniques that I find useful in creating an overall sense of balance and coherence in a painting. As I have explained (see page 14), I always keep to a limited palette of colours for the principal areas and effects – usually just two colours – and this invariably helps in developing a strong, unified composition. Additionally, I like to create a rhythm and pattern of shapes echoing throughout the

below: *The Harbour, Lipari*
mixed media on mountboard
51 x 71 cm (18½ x 25½in)
For a painting to be successful, all the main elements – the shapes, colours, textures and design – must work together to produce a coherent, interesting visual statement.

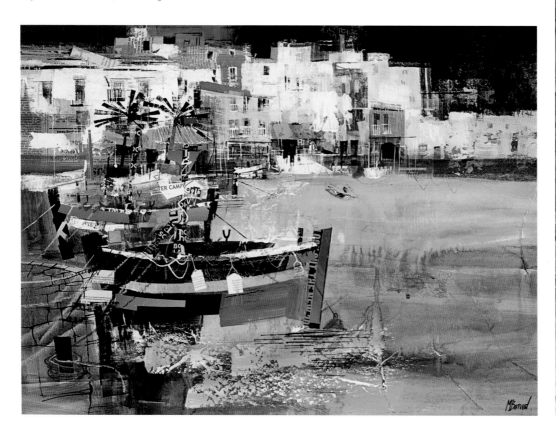

work, and I often use washes of acrylic ink. These will link areas together, while still retaining the underlying textures and other interesting effects.

Snowy Back Gardens (page 82) is a good example of the way that a restrained use of colour can be an effective means of creating harmony and impact in a painting. Here, the colour is essentially monochromatic – relying on a range of blue tones, with just one or two touches of red collage to create a focal point. Also, there is a sense of unity achieved though the repetition and pattern of shapes and marks, most of which were made with a length of card and white acrylic paint, or white or black acrylic ink. For the snow effect, particularly in the foreground, I started with a dark underpainting and then, using a length of card, dragged white acrylic paint over it. I often use opposing tones or colours for the underpainting.

below: *Barga, Tuscany*
mixed media on mountboard
43 x 66 cm (17 x 26 in)
Working with a very limited palette of colours always helps in developing a strong, unified composition.

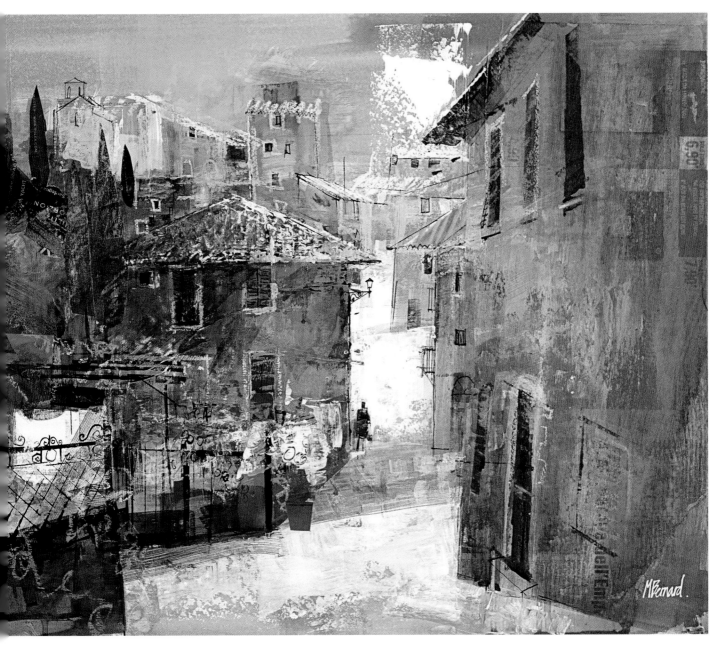

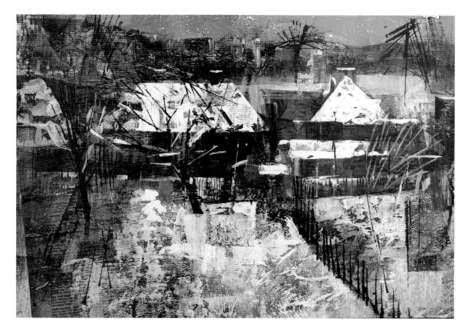

Similarly, in *St Ives Bay* (right), there are colours, shapes and effects that echo around the painting. The red chimney shapes are paper collage, which I sometimes use in the same way that I would use paint – just dotting it around the painting to create visual links. As you can see, this subject encouraged a more graphic approach than usual, and to suggest the different textures and details I have drawn with a dip pen, acrylic inks, oil pastels and a rigger brush (a thin brush with very long bristles).

Technical considerations

When working with water-based and drawing media, there are no real limitations as to the combinations and techniques that can be used. These media are entirely compatible and consequently the physical composition and durability of the painting should be fine, providing of course that good-quality materials are used. Together with the subject matter and choice of media, the main factors to think about are the size for the painting and the type of support to work on.

Suitable supports include watercolour papers, mountboard, canvas, MDF (medium-density fibreboard) or hardboard. It is important that the support is of an acid-free material and, in the case of canvas or board, is prepared appropriately. I occasionally use paper for some of the smaller paintings, preferring a stretched, smooth-surfaced, HP (hot-pressed) paper. This is less absorbent then other types and so the colours remain quite fresh and intense.

However, for most paintings I use a sheet of white or cream mountboard, which I staple to a backing board. For me, mountboard does not require any initial preparation, because once I have applied a layer of collage, this acts to reinforce and size the surface. Another advantage is that mountboard is easy to cut. I often start with a larger sheet than I need and, as it were, let the painting find its own size. For paintings larger than about 61 x 61 cm (24 x 24 in), I choose MDF or hardboard, which I prepare with a coating of white acrylic primer. When finished, I varnish the paintings with a coat of undiluted acrylic medium to seal and protect the surface. I make my own varnish by mixing equal amounts of matt and gloss acrylic medium.

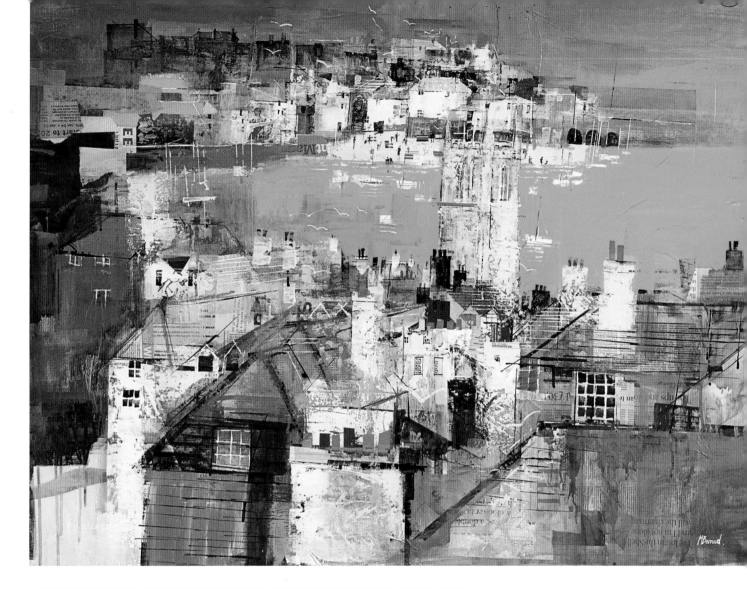

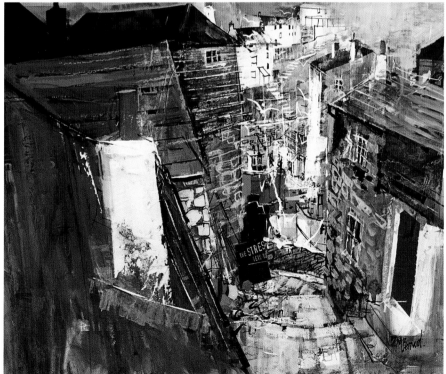

above: *St Ives Bay*
mixed media on MDF
91.5 x 112 cm (36 x 44 in)
For a large painting such as this, I
prefer to work on MDF (medium-
density fibreboard), which I prepare
with a coat of white acrylic primer.

From start to finish

Port Isaac in Blues

Inspiration

This painting includes an interesting range of media and techniques, which I felt worked well in successfully capturing the mood and interpretation I had in mind. I was also pleased with the balance between elements that are obviously representational and the areas that have a more abstract quality, as in the foreground. Also, with its repetition of shapes, such as rooftops, windows and chimneys, especially on the right-hand side, I think the painting has a strong sense of movement and energy.

Technique

I envisaged this subject as essentially a tonal painting, and therefore I kept to a very limited colour palette based on warm and cool blues and blacks. The restricted colour range helped in creating balance and harmony in the composition and also in conveying a feeling of space and recession. I am always intrigued by the fact that, when used in conjunction with mixed media, and consequently different surface textures, a limited palette will give a surprising variety of colour tones and effects. In this painting, for example, although in places I used the same blue, it looks quite different when applied over the rough texture of some of the paper collage, as opposed to a smooth area elsewhere.

For some shapes – some of the chimney stacks, for example – I used coloured-paper collage, and in other areas I worked with oil pastel or acrylic ink; similarly, these marks and shapes added to the variety within the colour range. I also wanted a specific light effect for the painting, to enhance the reflective mood of the scene. I decided to have a very light sky area, blocked in with white acrylic paint, which could then be echoed on parts of the buildings and in the foreground.

right: *Port Isaac in Blues*
mixed media on mountboard
51 x 61 cm (20 x 24 in)

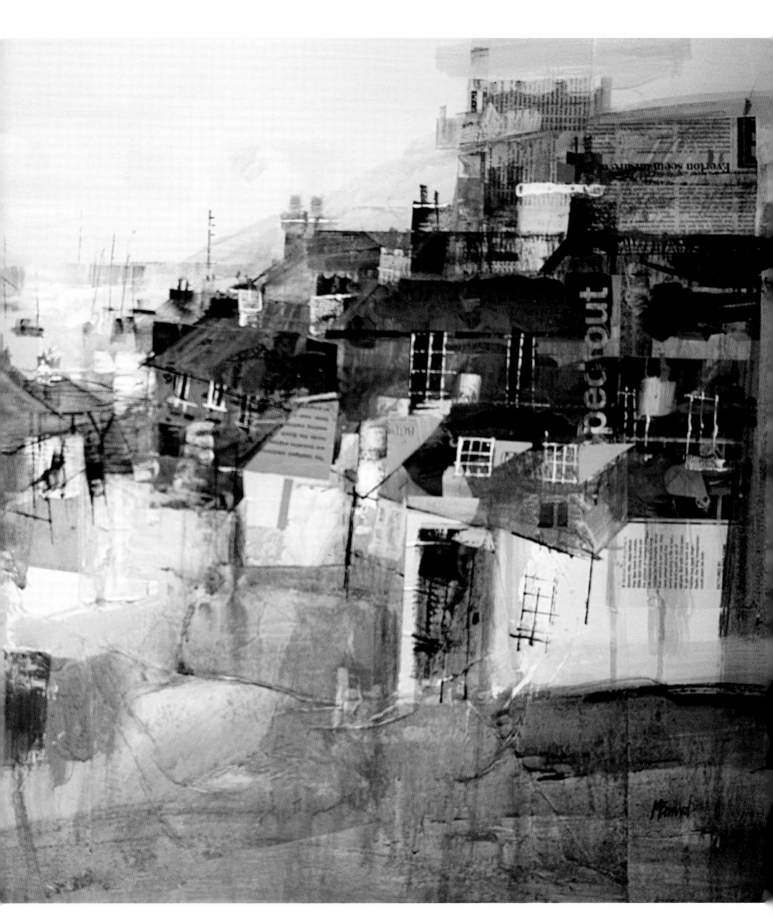

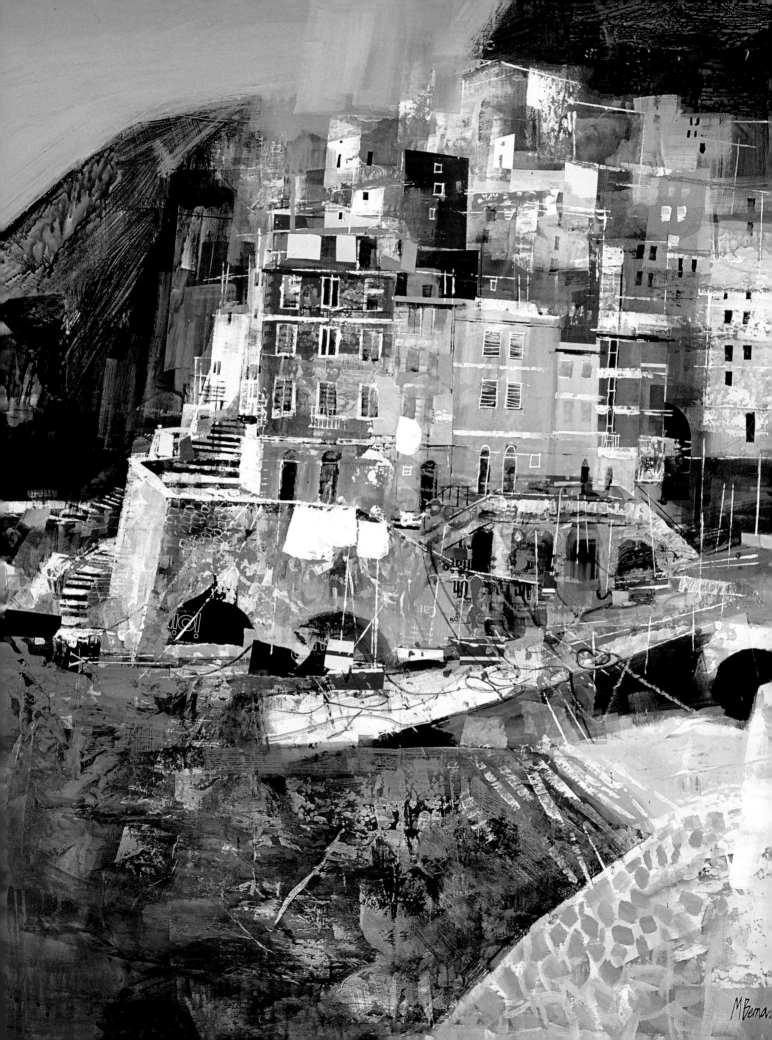

4 Colour and Texture

In every painting, it is the surface quality that interests me the most. For this, to achieve appropriate, exciting effects, I rely principally on colour and texture. Colour and texture create the distinctive, defining character of my work, I hope, and it is by exploiting the potential of these two fundamental, complementary elements that I am able to fully express my thoughts and feelings about each new idea or subject. Usually, I start with texture and then consider how to develop the painting in terms of colour. But the two aspects are closely interlinked, of course, so that certainly in the later stages of each painting I am considering texture and colour as one.

Where my painting process differs most from the conventional approach is at the beginning. Initially, I work with collage, but at this stage I prefer not to be influenced by any reference to the particular subject matter. Instead, I am thinking of texture for its own sake. I want an interesting, exciting foundation of texture to work from. Eventually, I start to build a relationship between the marks, textures and areas of colour that are beginning to shape the painting, and the subject matter I had in mind when I started. Usually this happens of its own accord, through subconscious decisions rather than thoughtful deliberation. And interestingly, the way that I suggest or define the subject matter is often largely through a process of elimination – of simplifying or blocking out areas – rather than adding to what is already there.

left: *Riomaggiore, Cinque Terre*
mixed media on MDF
91.5 x 91.5 cm (36 x 36 in)

below: *Morning Light, Portsmouth Harbour*
mixed media on MDF
51 x 76 cm (20 x 30 in)
To capture the particular effect of light and mood for this subject, I worked with a much more subdued colour palette than usual.

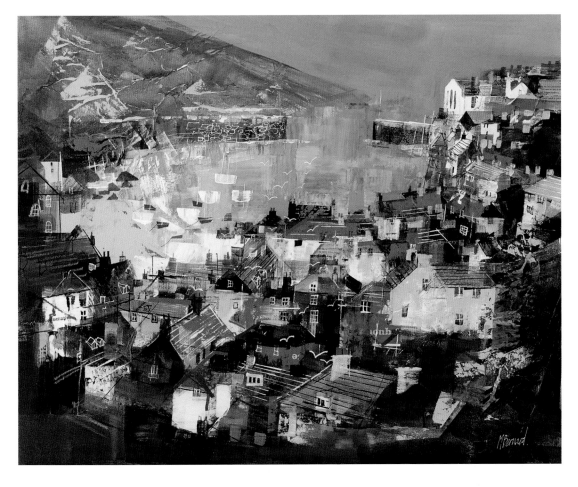

Subject, mood and colour

Although I always consider mood to be an important element in a painting, again it is usually not something that is planned from the outset. As the painting takes shape, and according to the decisions that are made, so the mood develops. Generally, I would not set out to create an evening scene, for example. Rather, the sense of 'evening' would evolve and be relative to the colours and techniques that I chose while making the painting. However, once I become aware of a certain mood developing, I might enhance it in some way.

Having said this, when I choose a subject to paint, there is probably something at the back of my mind that, later on, will influence the colours that I use and consequently the mood of the painting. And in fact, occasionally I might well choose colours that are directly related to the subject matter. For instance, I remember once making a painting of an orchard in which there were daffodils, and this inspired a yellow colour scheme – even though I did not include any daffodils!

Colour always has an emotional impact, and in every painting I am conscious that I must be bold with colour. I like colour to be intense and positively add to the statement of a painting. Quite often, my choice of colours is based on a warm/cool contrast. This was so for *Italian Riviera, Portofino* (below), which is an example of one of my more literal uses of colour. Here, when the painting was under way, I decided that I wanted to emphasize the impression of a sunlit Mediterranean scene.

below: *Italian Riviera, Portofino*
mixed media on MDF
76 x 91.5 cm (30 x 36 in)
Even when I adopt a more descriptive approach to colour, I still want it to be bold and intense.

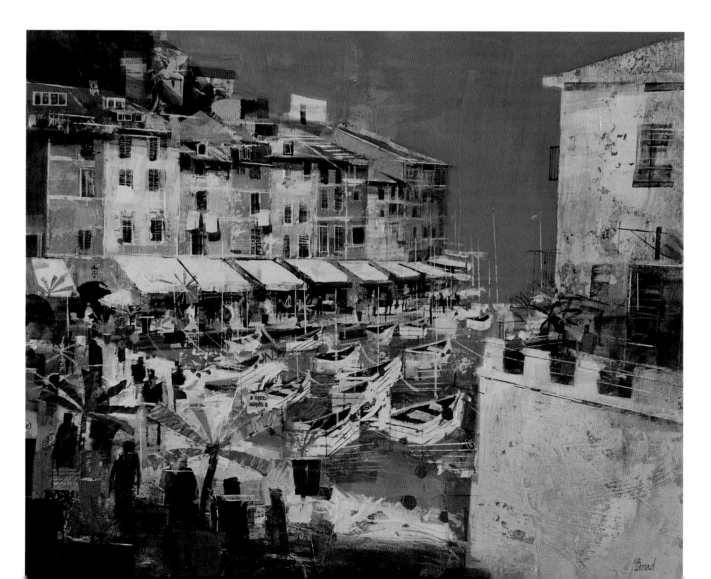

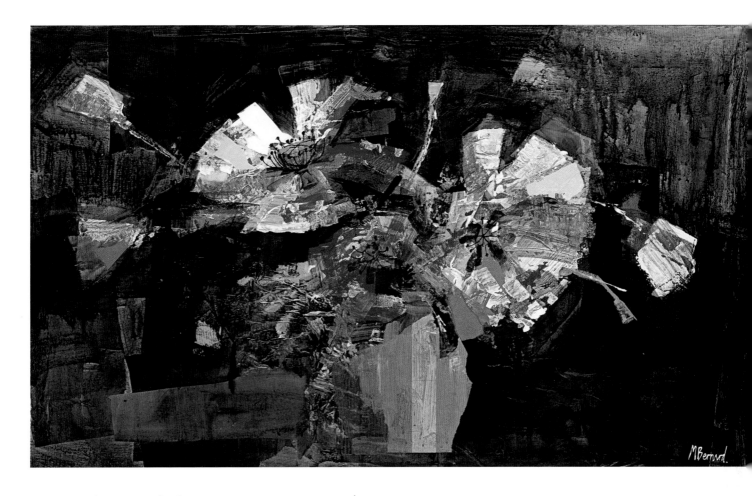

Colour characteristics

Like most artists, initially I followed the conventional approach to colour, based on observation and trying to represent exactly the colours I saw. I think it is difficult to be a landscape painter and not strive to capture the colours in nature, particularly at the start of one's career. But I soon wanted a more individual approach, and consequently I decided to abandon the quest for realism and work with colour in a more contrived way, involving aspects of colour theory.

This coincided with my interest in the Impressionists and especially the way they used colour to convey the effects of light and mood. I did not set out to copy them, but I was very keen to experiment with a limited palette of colours. This is something I pursued, working with colour harmonies and eventually restricting the choice to perhaps just two or three colours. I became increasingly aware that, when painting outside, directly from the subject, it was extremely difficult not to be influenced by the colours I saw. However, I found that if I made notes and sketches, and then distanced myself from the actual subject by painting it in the studio, it gave me more scope to explore colour in a personal and exciting way.

So, my approach to colour has become more instinctive. I want colours to be bold and exciting, to add to the interest and impact of a painting, but also to create a sense of unity. In fact, I find that when working on location the colour is seldom quite as dramatic or atmospheric as I would like it to be, and therefore it is an advantage to impose my own colour scheme on the subject.

As I have suggested, colour theory can be a good starting point for expressive work of this nature. However, in my view, it should never be allowed to dominate

above: *Californian Poppies*
mixed media on mountboard
46 x 76 cm (18 x 30 in)
Strong contrasts of colour, particularly with complementary colours, will always add to the impact of a painting.

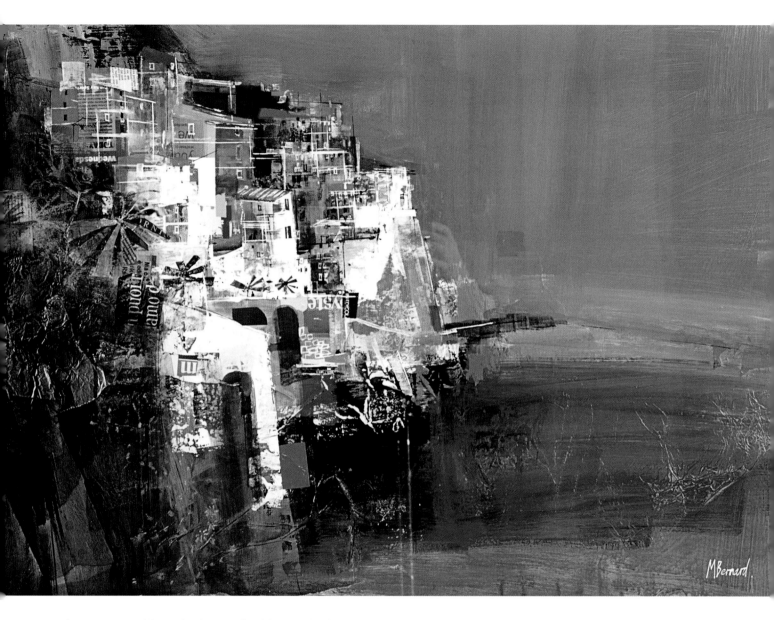

above: *Manarola, Cinque Terre*
mixed media on MDF
61 x 86.5 cm (24 x 34 in)
I find that Mediterranean subjects invariably inspire a very positive response to colour.

the process, as this can lead to predictable, contrived-looking results. A knowledge of basic colour principles and an understanding of analogous, harmonious, complementary colours and so on will provide a useful basis from which to develop ideas about colour, and there are many books and courses available, should you wish to study colour theory in more depth. Ideally, this sort of grounding in colour should give you greater confidence to work in a more adventurous and individual way.

Selecting a colour palette

I prefer to work with a very limited colour palette. The advantages of this are that it makes it easier to create a sense of harmony in a painting and control the tonal values, and also it helps in developing interesting atmospheric qualities. If there is a wide range of colours, this can lead to confusion and undermine the strength of the composition and the general impact of the painting. Also, by limiting the colour palette, you reduce the temptation to include lots of 'local' colours (the actual colours of the different objects and surfaces) in the painting, which can be counterproductive in creating powerful, expressive work.

Most of the colour effects in my paintings are made with acrylic inks or collage. Essentially, I work with two colours of acrylic ink, usually a contrasting warm/cool combination. But, as well as varying the strength of these colours, depending on how much they are diluted with water, I might also create different tones by mixing the coloured inks with black, sepia or white ink. Initially, I don't mix the main colours together on the palette, but instead allow them to intermix on the painting surface. I spray the surface with water and then apply the inks wet-into-wet so that they run together in places and make interesting effects. For occasional specific colours that cannot be mixed with the acrylic inks, I use collage.

For *Boat Repairs, Polruan* (below), you can see that I have kept to a cool palette of three blues. This gave me the opportunity to explore different atmospheric effects and aerial perspective. Similarly, in *Autumn in Venice* (page 92), the limited use of colour has a strong unifying quality as well as creating a particular mood. As always, the aim was to convey the essence of the place, rather than depict every building. Having started with a golden yellow and a sepia colour, the mood more or less developed of its own accord.

below: *Boat Repairs, Polruan*
mixed media on mountboard
48.5 x 74 cm (19 x 29 in)
With a cool palette of blues, made by mixing acrylic inks, I was able to create a dramatic atmospheric effect in this painting.

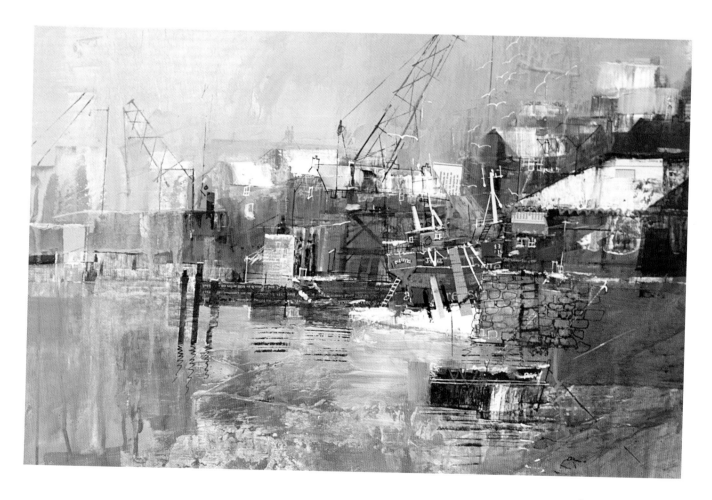

Expressive colour

My use of colour is expressive rather than descriptive. I am more interested in the fact that a colour is working to the overall benefit of a painting and in conjunction with texture and other qualities than helping to convey an exact likeness of the subject matter. Sometimes I am inspired by key colours within the subject matter itself and I will develop a colour scheme from there, but usually the colours I choose are deliberately arbitrary. They challenge any general intentions I might have for the painting, which I think is a good thing, because it ensures that nothing becomes too defined too quickly.

This point is demonstrated in *Taormina, Sicily* (below), in which the colours bear little relationship to those that were actually there. Instead, I deliberately kept to a limited palette of colours that would encourage expression and mood. Similarly, the colour additions made with collage, such as those for the shop awnings, had no connection with reality. They were included to add excitement and to enliven the result.

below: *Taormina, Sicily*
mixed media on hot-pressed watercolour paper
48 x 61 cm (19 x 24 in)
Often, my choice of colours is intuitive and allows me a free hand with expression and mood, rather than being specifically influenced by the original subject matter.

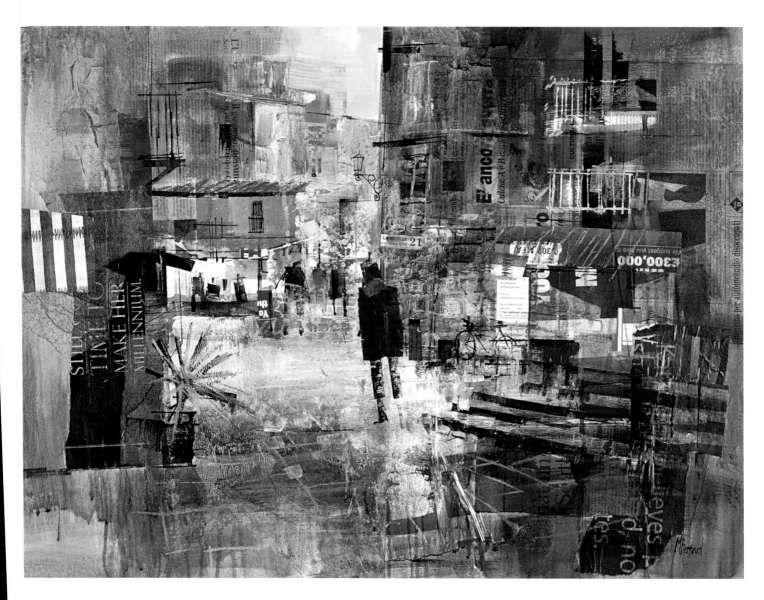

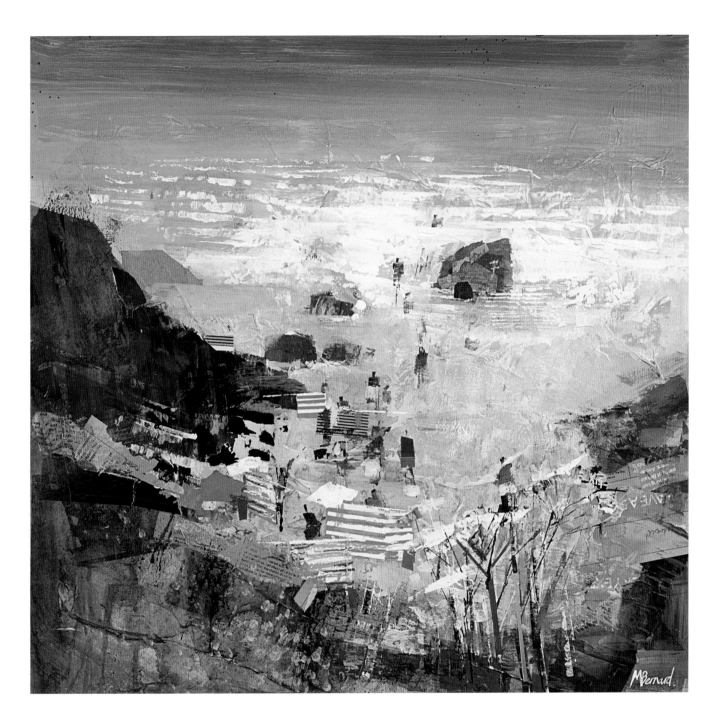

above: *Summer Sands, Cornwall*
mixed media on MDF
61 x 61 cm (24 x 24 in)
Success with colour, as with other aspects of
painting, often relies on simplifying or
exaggerating a certain approach or effect.

Scottish Harbour (below) and *Sunlit Harbour, Polperro* (right) show contrasting approaches. Whereas in the first painting I have utilized those aspects of the subject matter that would help me create a colourful, expressive image – although still responding in a personal rather than a conventional, representational way – in the second painting my approach was much more intuitive and spontaneous. Interestingly, in this painting a key consideration was the textural quality of the paint, and to achieve this I used tube acrylic paint rather than liquid acrylic inks. This was the sort of painting in which I could allow myself to fully engage with the handling of paint and colour, and focus on the needs of the painting itself, rather than think too much about the content or how best to depict the subject matter.

below: *Scottish Harbour*
mixed media on MDF
61 x 61 cm (24 x 24 in)
Here, the subject matter did have colour
qualities that I wanted to utilize, although
note that I have responded in a personal
way and did not just rely on reproducing
the colours that were there.

right: *Sunlit Harbour, Polperro*
mixed media on MDF
61 x 61 cm (24 x 24 in)
In this painting I particularly wanted to
achieve a bold, textural quality and so
I decided to use tube acrylic colours
rather than liquid acrylic inks.

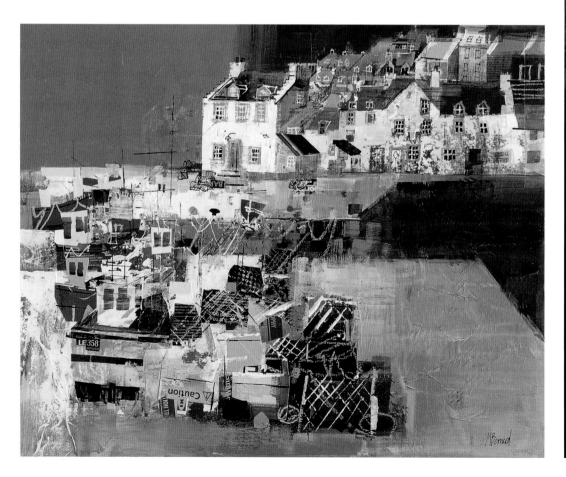

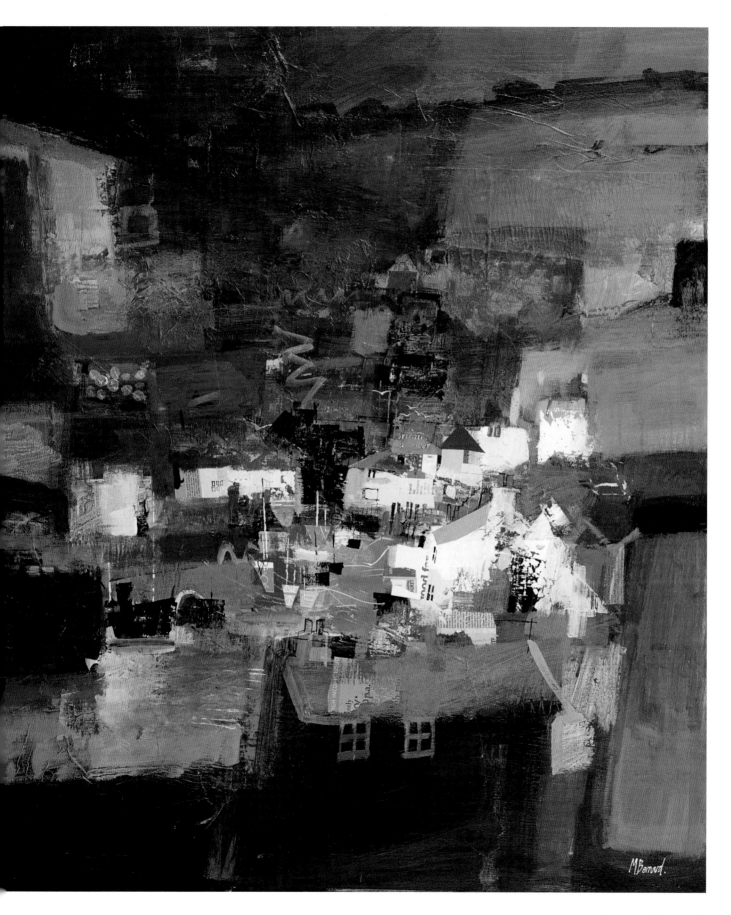

MBernard.

Colour and design

As I work with colour, whether in the form of collage or acrylic paint or inks, I am conscious of the part it plays in enhancing the sense of design within a painting and its overall impact on the viewer. Often, I use patches of a certain colour as 'stepping stones' to carry the eye around a painting and so create a connection between one area and another. In fact, this is my main device for linking different elements of a painting together. These accents and shapes of colour also add a rhythm and energy to the work.

In *Market Day, Le Marche, Italy* (opposite, bottom), for example, I have used patches of yellow as the main linking device. As here, I often find that collage works best: it is a more direct technique and easily adjustable. With a cut or torn paper collage shape, you can position it and check to see how it looks, and if necessary replace it with a different shape or move it, before gluing it in place. But if the shape is made with paint, acrylic ink or oil pastel, it is not so easy to correct or reposition. You can usually find a reason for including such shapes – perhaps a lemon on a market stall, a shop sign or, as in *Sidmouth Beach* (right), a towel on a beach. And another advantage of these coloured shapes is that, by varying their size and tone, they will add to the sense of recession and movement in a painting.

below: *Shopping, Venice*
mixed media on mountboard
37 x 51 cm (14½ x 20 in)
Colour inevitably plays an important part in the design of a painting. Note here how the 'blocks' of colour add impact to the composition.

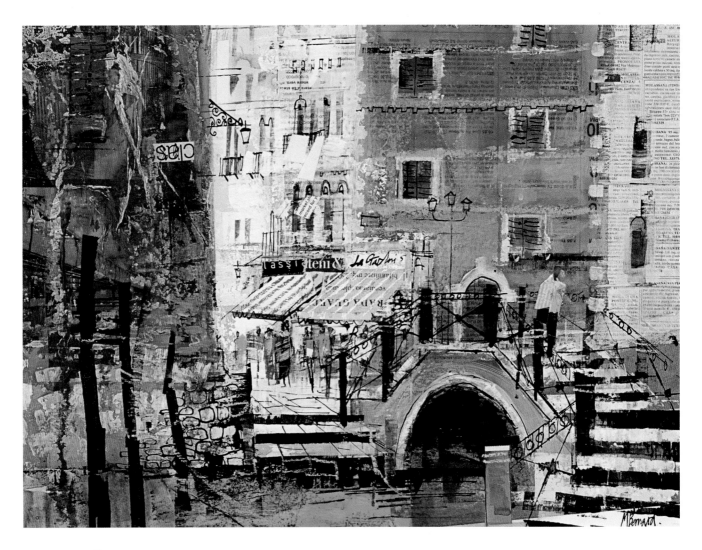

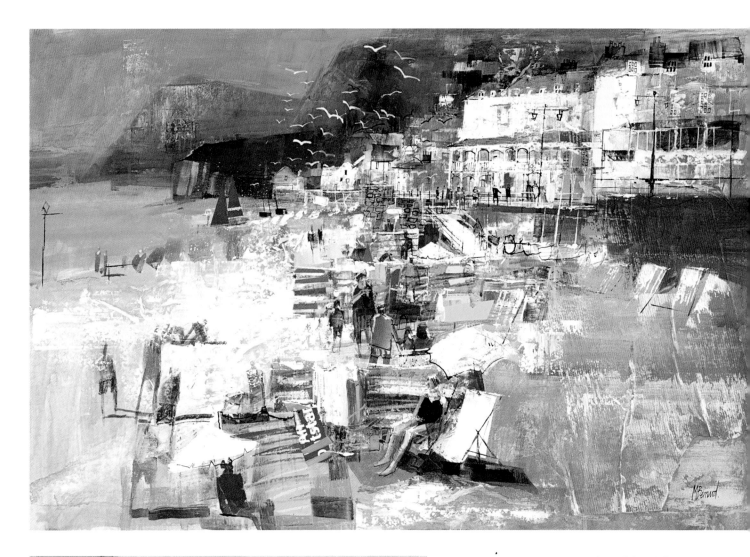

above: *Sidmouth Beach*
mixed media on mountboard
53 x 79 cm (21 x 31 in)
By working with the same colour, but
varying the size and tone of the repeated
shapes, you can create a sense of
recession and movement in a painting.

left: *Market Day, Le Marche, Italy*
mixed media on MDF
76 x 91.5 cm (30 x 36 in)
As with the patches of yellow in this example,
I like to repeat an appropriate colour around
the painting and so create a connection
between one area and the next.

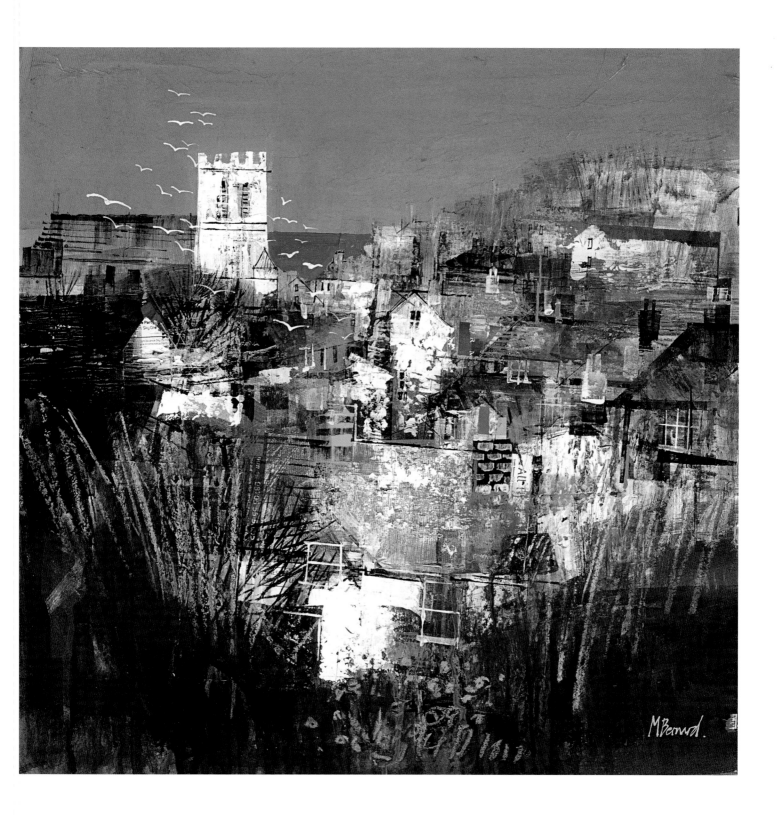

above: *Beer Rooftops*
mixed media on mountboard
48 x 48 cm (19 x 19 in)
Here again I have used the card technique
quite extensively to block in areas of colour
and offset lines and textural effects.

Impasto effects

Texture can be used purely for its own sake, to enliven parts of a painting, or it can be applied in a more considered way, to help define and convey particular surfaces or features within the subject matter. Although realism is never my objective, nonetheless, for each painting to work successfully and capture a sense of place, it must include some references to reality. I like the contrast between abstract qualities and representational elements. With textures, this means that some are included to add interest, and are incidental to the subject matter, while others are more descriptive in nature.

Most of my paintings have a textural quality all over, whether for the sky or the more obvious textured surfaces such as stonework. Usually, I concentrate specific textures and details around the focal point of a painting, adopting a broader, more expressive treatment for the outer areas. The textures can be deliberately heavy impasto in places, built up with white acrylic paint and subsequently worked over with coloured glazes or oil pastel.

For certain effects, such as an Italian pantile roof, I apply acrylic paint with the edge of a piece of card, so as to suggest the ridged surface. When dry, this is coloured, perhaps using an ochre or orange oil pastel. I also use the card technique to repeat lines, add details and, by dragging one colour over another, create a broken-colour textural effect. See *Alleyway, Sicily* (below).

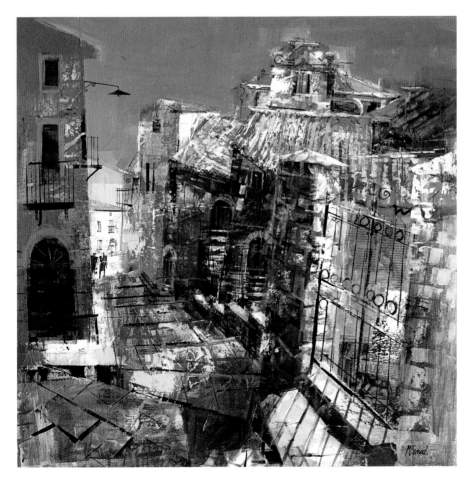

left: *Alleyway, Sicily*
mixed media on mountboard
61 x 61 cm (24 x 24 in)
Rather than using a brush, I apply a lot of the colour by working with pieces of card and using them rather like a palette knife, dragging one colour over another.

Varied techniques

For *Crail Harbour, Fife* (below), I used the card-and-acrylic-paint technique to create the textures in the water and on the harbour wall. For this technique, I cut the card to whatever size is appropriate. Generally, in the early stages of a painting, I work with quite large pieces of card, perhaps up to 10 cm (4 in) wide. I use the card rather like a painting knife, loading it with paint and then holding it almost horizontal to the painting surface and pulling it across an area. Such textures work particularly well over collage. Also, I sometimes use the corner of a card, dipped in paint or acrylic ink, to make dots, small marks and details.

Alternatively, I apply paint with a roller to produce texture. I use a 7.5 cm (3 in) lino-printing roller for this. First, I put some white acrylic paint on the palette, then I charge the roller with paint and roll it across the appropriate part of the painting. Again, depending on the surface to which the paint is applied, and the amount used, this will give a solid, impasto texture or a more random, broken texture. When it is dry, I usually add a coloured glaze over this type of texture.

I use clingfilm, sponges and brushes to create other interesting textural effects. I place the clingfilm on an area of wet acrylic ink or diluted acrylic paint in part of the painting, leave it to dry, and then remove it. This will produce random pattern and paint effects, which might suggest water, for example, or a rocky surface. However, this is more of a chance technique than something that can be relied upon to create a specific result. For another type of broken texture I use a small piece of household sponge dipped into acrylic paint or ink, which I then dab across the chosen area. Similarly, stiff-hair bristle brushes are useful for stippled and dry-brush effects.

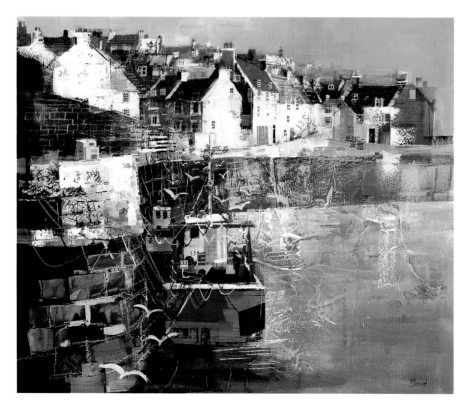

left: *Crail Harbour, Fife*
mixed media on MDF
76 x 91.5 cm (30 x 36 in)
In this painting I used card to apply the acrylic paint and create the texture in the water and on the harbour wall.

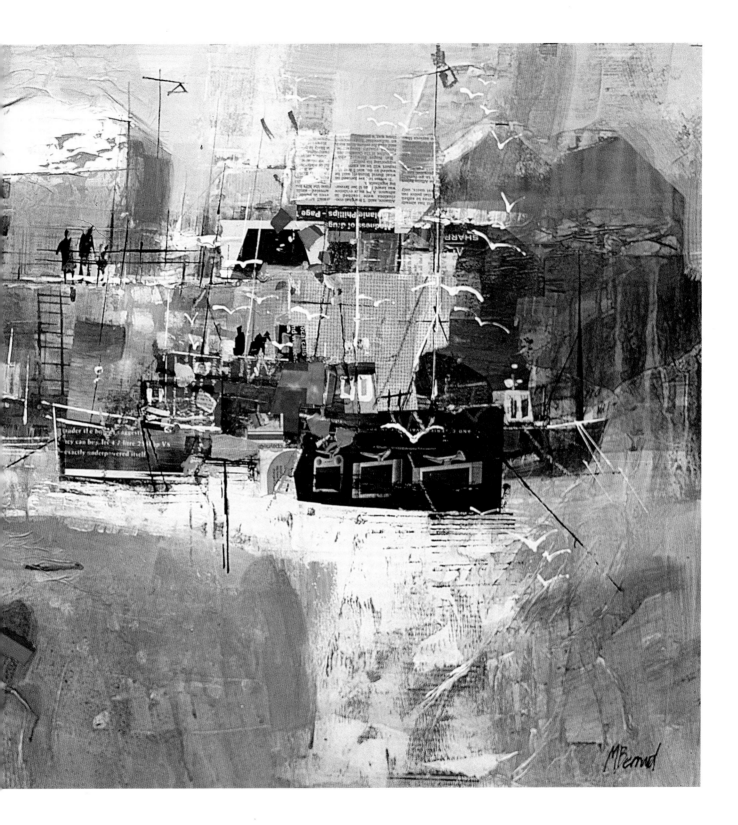

above: *Emsworth Harbour*
mixed media on mountboard
51 x 70 cm (20 x 27½ in)
When introducing a different technique, check that as
well as suiting a certain area or effect, it contributes to
the overall intentions and impact for the work.

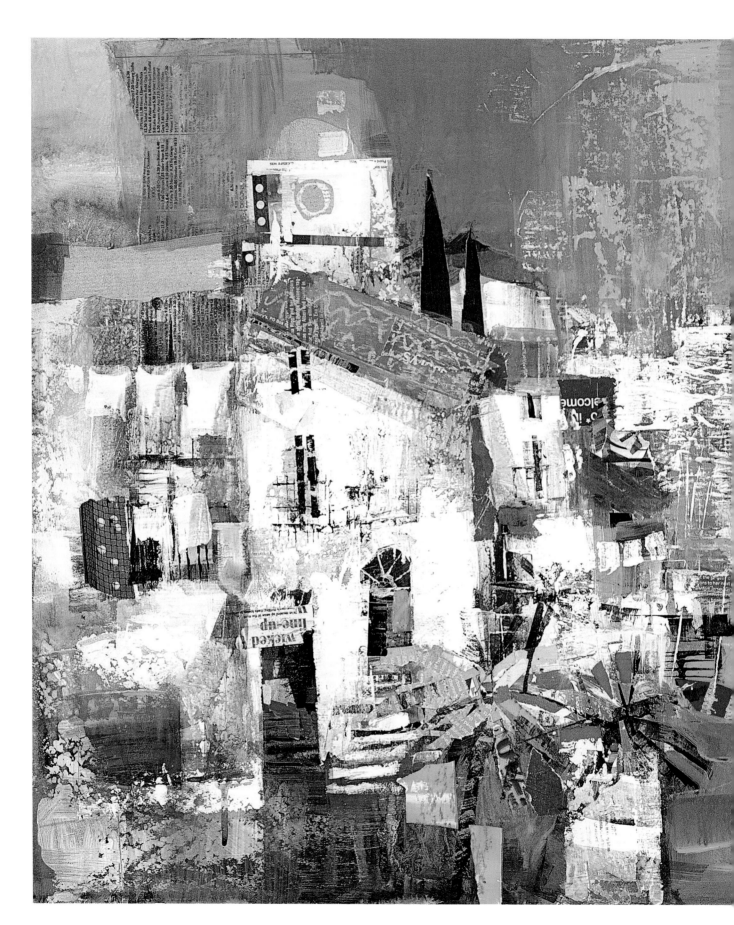

From start to finish

Italian Harbour

Inspiration

The inspiration and reference information for this painting came from a photograph, although I have greatly adapted what I saw in the photograph and combined fact and fiction. For example, the buildings were not white, but I have allowed them to be so, influenced by the initial work in white acrylic paint.

Technique

I used a variety of colour and textural techniques in this painting, which I started in the usual way with an underpainting of collage and white acrylic paint. In the vertical stripes of white and blue that form the background of the painting, there is clear evidence of the use of a roller. You can also see that some of the initial collage has been left to suggest different shapes, such as the newsprint 'building' on the far right. Here, the newsprint texture suggests brickwork, with the dark-toned photographs implying windows. In other areas, while the white paint was still wet, I used a piece of card to lift out the shapes of windows and doors. As I did this, quite by chance, it revealed some of the dark paper collage beneath, thus enhancing the sense of depth inside the buildings.

In the centre and foreground areas, the boats and palm trees were built up with paper collage, and in places I worked over these surfaces with oil pastel to add further texture and definition. The remaining drawing and detail was made with pen and ink. For this I used a dip pen and black and white acrylic inks. Features such as the divisions of the windows were added in this way. Essentially, the painting has the balance of abstract and representational qualities that I like. There is no obvious attempt at perspective, for example. Instead, there is an overall sense of pattern, made with horizontal and vertical shapes.

left: *Italian Harbour*
mixed media on mountboard
51 x 68.5 cm (20 x 27 in)

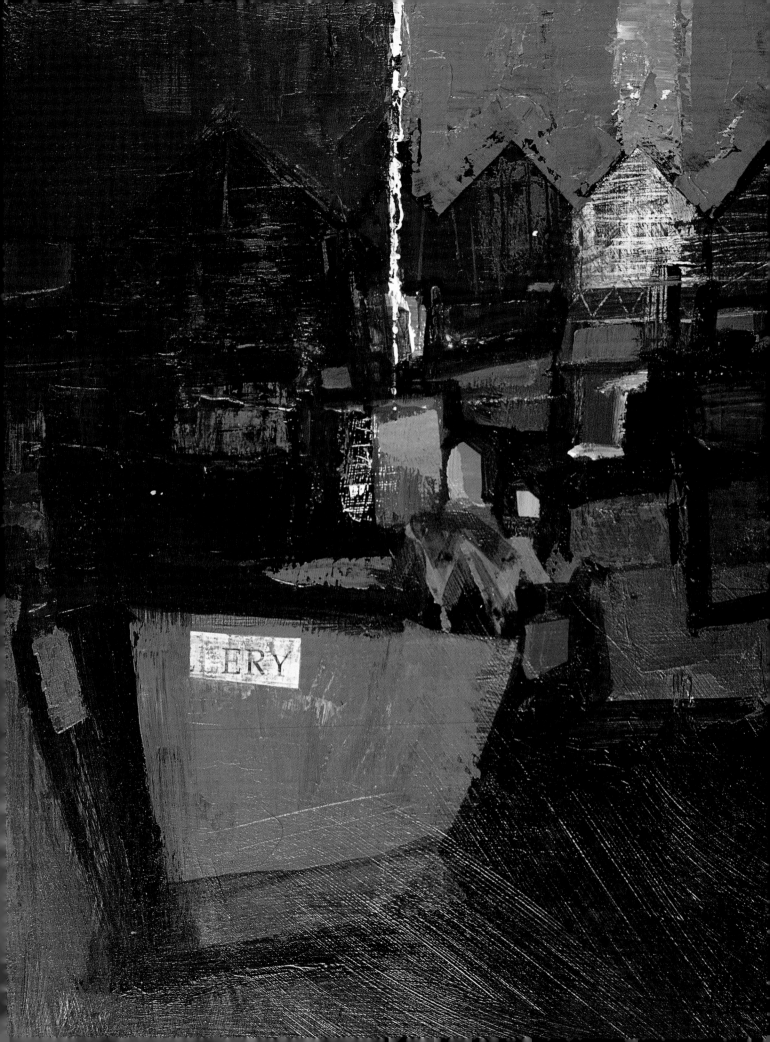

5 Developing Ideas

For me, success in developing an idea relies on creating the right balance between working freely and applying some control. My inclination is to paint intuitively. However, to achieve a result that is visually strong, interesting and connects with the place or scene that was my initial inspiration, there are obviously times during the painting process when I need to adopt a more considered approach.

Generally, I start with chaos – a free and expressive use of collage and colour. Then, the challenge is to bring some order into that chaos, and so define the essence of the subject or idea. I have always thought it best not to start with a great deal of planning and preparation, but instead to keep an open mind as to how a painting might develop.

Studio practice

Commitment is an essential quality for any artist. You have to be prepared to work hard and persevere, especially when things aren't going as well as you had hoped. I paint in my studio most days, sometimes well into the evening. I am fortunate nowadays in that I am always working towards the next exhibition, which I find is a good incentive, a great inducement to be disciplined! But it is also healthy, I think, to want a distraction sometimes, and so take a short break from painting. This helps to keep the work lively and interesting.

below: *Ilfracombe*
mixed media on mountboard
51 x 68.5 cm (20 x 27 in)
From the 'chaos' of the underpainting, with its free and expressive use of collage and colour, I work to establish some order and so define the essence of the place or idea I have in mind.

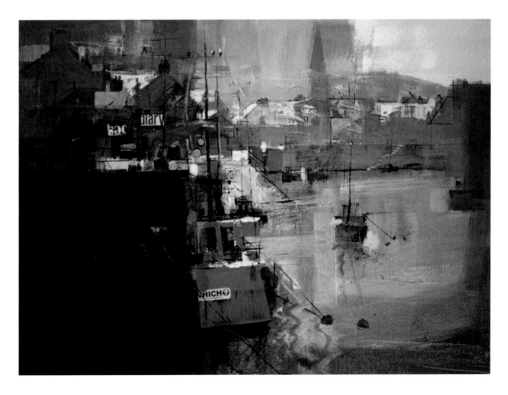

left: *Red Abstract*
mixed media on hardboard
38 x 30.5 cm (15 x 12 in)

Work in progress

Photographs can be a useful source of reference, especially for the general shapes within the subject matter and the overall sense of design. But I never use them for colour reference: they are much too informative in this respect. It is far better, for the harmony and impact of a painting, to create your own colour scheme, I think. In fact, as demonstrated for *Berwick Street Market* (Stage 1), I quite often work only from a location pencil drawing, as this leaves me with complete freedom when it comes to making decisions about colour.

Now, I usually start each painting with collage, before introducing colour and texture. But earlier in my career I would often begin by blocking out the white painting surface with colour washes, and this was the method used for *Berwick Street Market* (Stage 2). First, I dampened the paper, using an ordinary plant sprayer, and then, working with the two basic colours – a warm and a cool colour – and a big brush, I quickly applied the washes, allowing them to blend slightly into each other.

Next (Stage 3), I used white acrylic paint, applied with a length of card and a roller, to place the light area between the buildings and the reflected light below. Also, I worked with collage, and if you compare this to the original location study, you will see that essentially I am 'drawing' with the collage to indicate the main shapes of the composition. Mostly I am using torn paper shapes, which, as well as preventing me from becoming too fussy, create a more interesting effect.

Thereafter, the process was one of gradually refining areas until I reached a result that I was satisfied with. I did further work with a small piece of card and white acrylic paint, to add price labels and other details on the market stall, and similarly, to suggest the shapes of the figures in the background by defining the surrounding spaces (Stage 4). I also added lines and details with the edge of a piece of card and pen and ink. Finally, I applied light colour washes where necessary to subdue areas, with further drawing in pen and ink to emphasize one or two features (Stage 5).

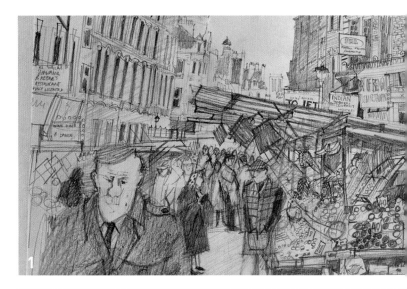

stage 1: *Berwick Street Market*
Location drawing on cartridge paper.

stage 2: *Berwick Street Market*
Blocking out the white paper surface with colour washes.

stage 3: *Berwick Street Market*
Working with white acrylic paint and collage to establish the main elements of the composition.

stage 4: *Berwick Street Market*
Further work with white acrylic paint to refine areas, and some drawing with a dip pen and acrylic ink.

stage 5: *Berwick Street Market*
mixed media on hot-pressed watercolour paper
48 x 66 cm (19 x 26 in)
To fully resolve the painting, I worked with colour washes made from diluted acrylic ink, and added a few details in pen and ink.

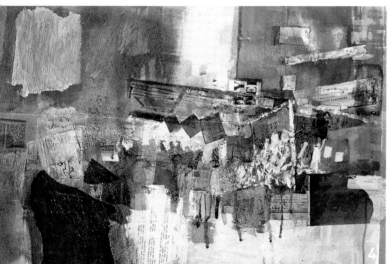

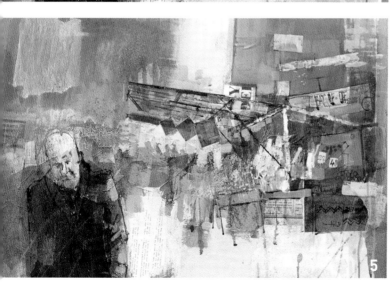

below: *Berwick Street Market* (detail)
This detail shows more clearly my use of different
materials and techniques: collage, colour washes and
pen-and-ink drawing.

Choices and decisions

In every painting there are hundred of decisions to make before you eventually reach a point when it is finished – when to do more would detract rather than add to its impact. Decisions can be made intuitively or with deliberation and consideration of particular requirements in the painting. Sometimes it is good to be spontaneous and act on your gut reactions to something. At other times you may want to add to the sense of recession, for example, improve the colour of something, or create more definition in a certain area, and this will need due thought and application.

Each decision will have a degree of impact on the painting as a whole. Indeed, some decisions can have a profound effect and completely change the mood or sense of direction for the work. Often, the key decisions relate to assessing whether to

below: *Red Fishing Boat, Port Isaac*
mixed media on mountboard
48 x 61 cm (19 x 24 in)
Generally, rather than cutting out precise shapes, I prefer the more expressive quality of torn collage, as with the many of the underlying collage shapes in this painting.

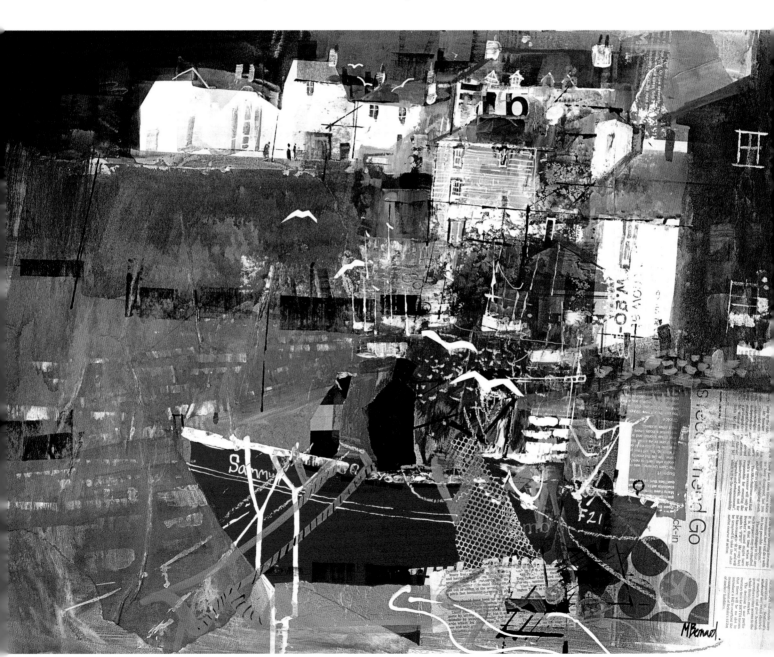

develop a feature or effect further, or whether to leave well alone. For many artists, there is a natural desire to perfect everything. But generally, perfection is a bad thing: it stifles originality and self-expression and makes a painting ordinary, rather than different and exciting. In most paintings, it is a matter of striking a balance between resolving areas and not doing too much.

In *Red Fishing Boat, Port Isaac* (left), for example, the main boat shape is quite a rough piece of collage, which I was going to refine. However, I decided to leave it, as I thought it looked better within the overall context of the painting, otherwise it would have been too precise. Also on the left-hand side, notice that there is a plain piece of newsprint on which there are some black circles. These have no particular meaning, but they are a way of ensuring that the painting does not become too elaborate; that it has contrasting areas of interest.

Sometimes it is necessary to take the hard decision to subdue or even eliminate something that has taken you much skill and time to paint. In *Harbour Wall, St Monans, Fife* (below), I originally included more buildings in the upper left-hand part of the painting. This created a rather top-heavy effect within the composition, and so I decided to paint over the buildings and leave this area as a more restful part of the painting, which would balance the area on the lower right.

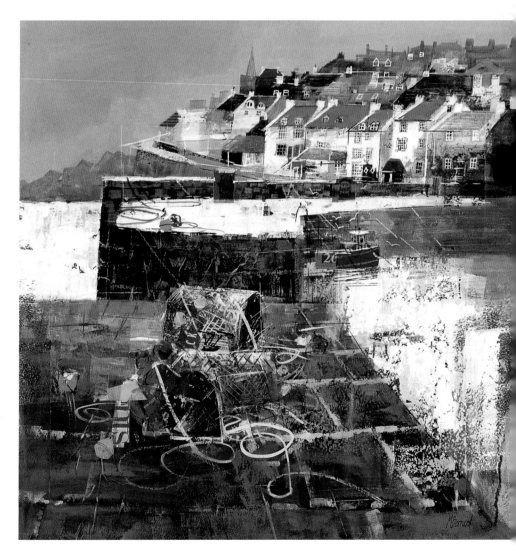

right: *Harbour Wall, St Monans, Fife*
mixed media on MDF
71 x 71 cm (28 x 28 in)
Sometimes it is necessary to simplify an area in order to create a more effective result overall. In this example, I originally included more buildings, but eventually I decided that the composition would work better if I simplified the top part of the painting.

Painting with confidence

For my large paintings, I work on sheets of acrylic-primed MDF (medium-density fibreboard). Naturally, the large scale offers greater scope for a variety of freely expressed techniques, as demonstrated in *Beer Beach* (right). In fact, this painting was a commissioned work for the owners of the house that is set amongst the trees in the background. The first problem I had to overcome was to somehow identify the house more prominently, as in reality it was well hidden by the trees. So I had to move it slightly in relation to its context. I made a location drawing (Stage 1) and took some photographs.

In contrast to *Berwick Street Market* (page 115), for this painting I began directly with collage (Stage 2). I used a variety of materials, including tissue paper, gold wrapping paper, newspaper, pieces torn and cut from magazines, and even part of a monoprint. You will see that the shapes roughly correspond to the main elements of the original drawing. For example, the red shape indicates the client's house, the brown areas on the left show the harbour wall, and the tissue shapes are the tree line. All the time I was trying to balance colour and texture, plain against print.

Next, using a lino-printing roller and some titanium white acrylic paint, I added random areas of light and texture. When these had dried, I sprayed the whole surface with water and applied the two basic colours – cadmium yellow medium (tube acrylic paint) and black FW acrylic ink – with a large brush, allowing them to blend, drip and run. Then, the surface was sprayed again, to encourage more drips and runs before – as shown in Stage 3 – I began to draw in the main outlines, using the edge of a piece of card dipped in black FW acrylic ink.

After assessing the development thus far, I decided to use more collage and acrylic paint to add some substance to the main shapes (Stage 4). I continued with this process (Stage 5), also enhancing the sense of depth and perspective. The blues – brilliant blue acrylic colour and bright blue collage – were introduced to heighten the overall impact and, where necessary, I started to draw and define shapes and textures.

To complete the painting (Stage 6), I worked on the detail, mainly using black and white acrylic inks and drawing with a dip pen. For example, I added the lobster pots and the post in the foreground, the masts and numbers to boats, and more detail to the house on the hill. I toned down some of the foreground colour and refined and unified the colour in other areas. The finished painting was varnished with copolymer emulsion and framed in the same style as an oil painting, without glass.

stage 1: *Beer Beach*
pencil on cartridge paper
Location drawing to show the main shapes and tones.

stage 2: *Beer Beach*
Starting with collage to suggest the basic layout of the painting.

stage 3: *Beer Beach*
Placing some of the key shapes by drawing with a piece of card dipped in black acrylic ink.

stage 4: *Beer Beach*
Now I am focused more clearly on the main elements of the painting, working with collage and acrylic paint.

stage 5: *Beer Beach*
Touches of blue acrylic paint and collage are introduced to add impact, and I am beginning to create a better sense of depth and perspective in the painting.

stage 6: *Beer Beach*
mixed media on MDF
91.5 x 122 cm (36 x 48 in)
To complete the painting, I worked on the detail, particularly in the foreground area.

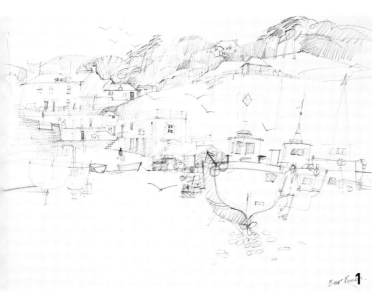

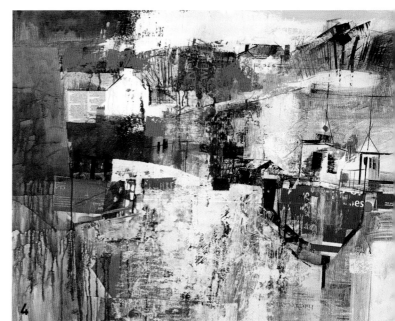

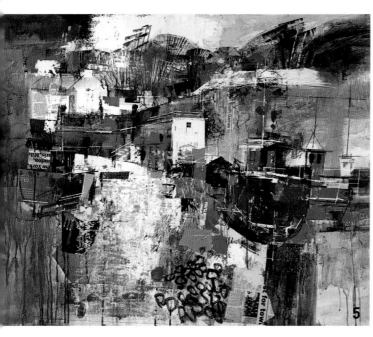

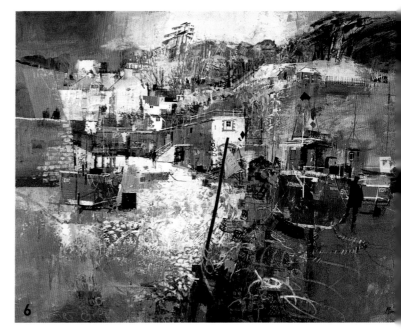

Experimentation

It is only natural that we should want to achieve the best possible result from each painting. However, somehow this must be accomplished with a reasonable degree of freedom and spontaneity, otherwise there is a danger that the finished painting, while perhaps very skilfully produced and accurate with regard to the original concept, will appear bland and unexciting. The quest for 'perfection' can bring with it the fear of making a mistake and, in consequence, an inhibited style of working. The temptation is to place all the emphasis on the way a painting looks when it is finished, rather than acknowledging what happens en route to the completed idea.

To encourage confidence and create the right balance between a carefully considered working process and painting intuitively, I think it is good to adopt a much more experimental approach occasionally. Very often, if there is no pressure to achieve a particular result and you are free to try out different techniques and ideas, the finished painting can be surprisingly effective. So, don't be afraid to treat some paintings in a purely experimental way: enjoy yourself and see what happens. You may have to throw the finished painting in the bin, but working with that sense of freedom is always valuable and invariably there will be discoveries and aspects of the painting process that may help inform future work. See *Kinsland Market* (below).

below: *Kinsland Market*
collage and acrylic on hardboard
91.5 x 122 cm (36 x 48 in)
Don't be afraid to experiment and try out new
techniques and ways of interpreting ideas.

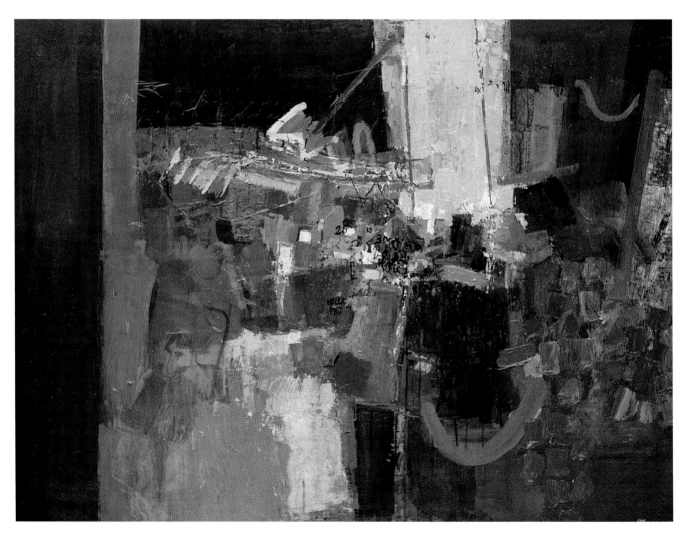

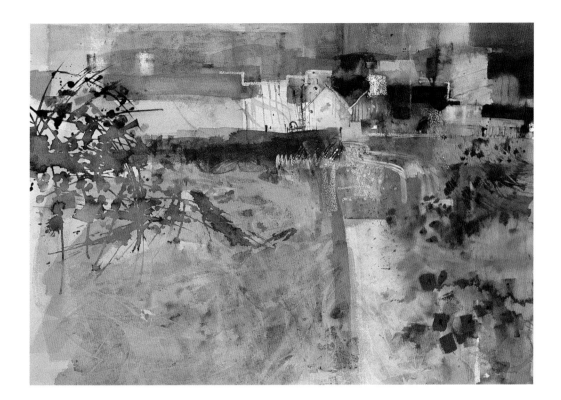

Ways and means

Today's artists can choose from a tremendous range of paints and other materials. However, although this has obvious advantages, equally there is the danger of confusion and unsound working practice. As I have stressed throughout this book, I think the most successful paintings result from an expressive yet disciplined approach based on self-imposed limitations. To create paintings that have a real sense of unity, integrity and impact, it is essential to keep within certain boundaries regarding colours, tools and techniques.

The best way to discover and gain confidence with different materials and techniques is by experimenting – by simply trying things out to see what happens. For example, start by considering the surface that you are going to paint on, as this can have a significant influence on the ultimate impact of the work. Rather than painting on white paper, card or board, try a textured or coloured surface. As an alternative to starting with paint or collage, you could use an old painting – perhaps a watercolour that you have abandoned – or work over a monoprint or photograph. Turn the painting upside down and, if you want to subdue its content, paint a very light wash of white acrylic over it. Similarly, you could use a discarded watercolour for collage work, tearing or cutting it into different shapes.

I have emphasized the advantages of keeping to a limited palette of colours, and in conjunction with this the choice of painting and mark-making tools is equally important. Again, limit your approach – use just one or two different tools. For instance, you might decide to use only a 5 cm (2 in) brush, which will both test your ingenuity and instantly encourage you to be more selective and economic with detail. In the same way, blocking in colours with a length of card, or using the edge of the card (dipped in ink or paint) to draw with, will produce interesting results and prevent the work from becoming too fussy. I also like to use rollers, sticks, feathers and sponges – anything but a brush!

above: *Hampshire Farm*
watercolour on Not watercolour paper
58.5 x 58.5 cm (23 x 23 in)
By imposing limits on the painting process, whether regarding colour or materials and techniques, you will ensure more control and confidence with the work.

Towards abstraction

Undoubtedly the subject matter and what happens during the painting process are influential factors in the degree of abstraction that is achieved, but some paintings naturally seem to lead to a more abstract result. *Looking Across to Port Isaac* (below), for example, includes very little that connects it to the real world – just an indication of rooftops and house shapes. Interestingly, like many of my larger, almost abstract paintings, this example was based on an earlier, more representational work. This is a much-proven way of developing an abstract painting, of course, by drastically simplifying the subject content. If you ignore the detail and view the subject matter purely in terms of shapes and colours, rather than thinking of specific objects, then inevitably the work will have a strong abstract quality.

Another key point is the notion of subject and background. In representational work, one of the most difficult things to achieve is a convincing sense of space and three-dimensional form. But this is seldom relevant in an abstract painting, as often the objects and spaces are treated with equal importance. In my paintings, I like to combine both abstract and representational qualities. For instance, I will use 'abstract' background shapes to define and give meaning to particular objects – the shape of a building, perhaps. I like the interaction of negative and positive shapes and, similarly, the contrast between expressive, abstract textures and colours and more obviously descriptive parts of a painting.

Perhaps in the future I may want to take the process further and paint with a greater emphasis on abstract qualities. But certainly at present, although abstract elements play an essential part in my work, I need to keep some association with reality. I think there is tremendous scope for creating exciting paintings in this way. As shown in the various demonstration paintings, such as *Beer Beach* (page 119), I always begin with pure abstract shapes and colours and develop the painting from that basis. In that sense, I work from abstraction rather than towards it. But I hope equally that I have shown the potential for abstract work, particularly with mixed-media techniques.

right: *St Mary's Market*
mixed media on MDF
91.5 x 122 cm (36 x 48 in)
I particularly enjoy subjects like this, in which I can create strong contrasts between abstract qualities and recognizable shapes.

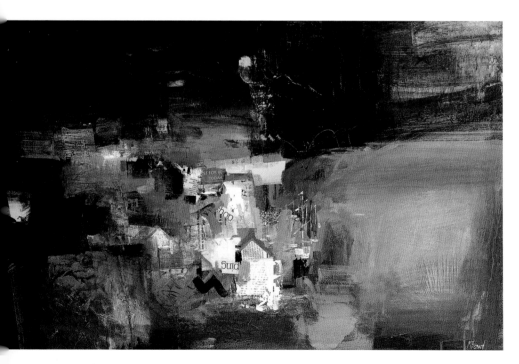

left: *Looking Across to Port Isaac*
mixed media on MDF
61 x 91.5 cm (24 x 36 in)
Some ideas encourage a much more abstract interpretation than others, although I always like to include some content that associates the painting with a particular place.

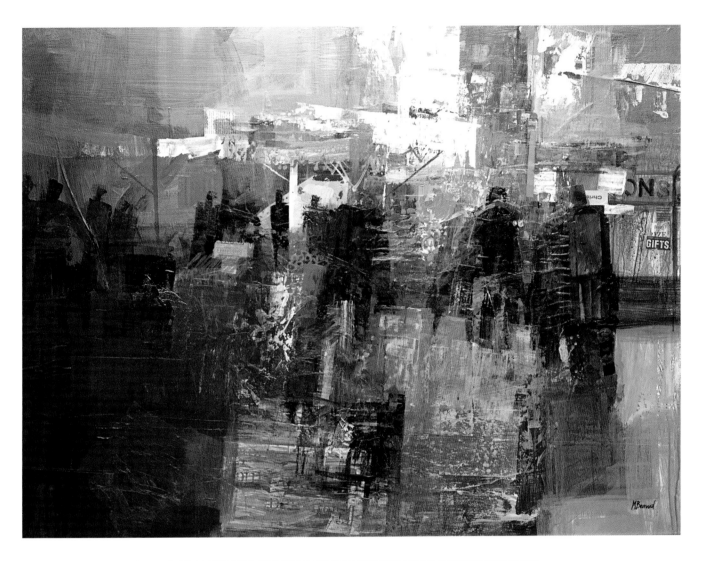

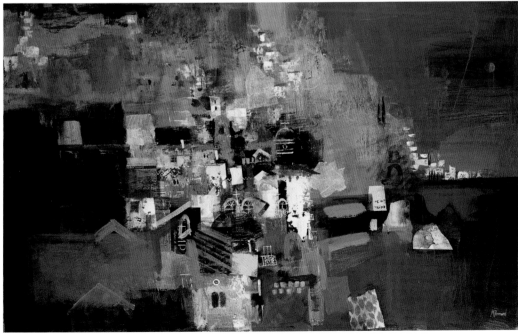

left: *The Amalfi Coast*
mixed media on MDF
76 x 122 cm (30 x 48 in)
Here there is a nice
balance, I think, between
representational and
abstract elements.

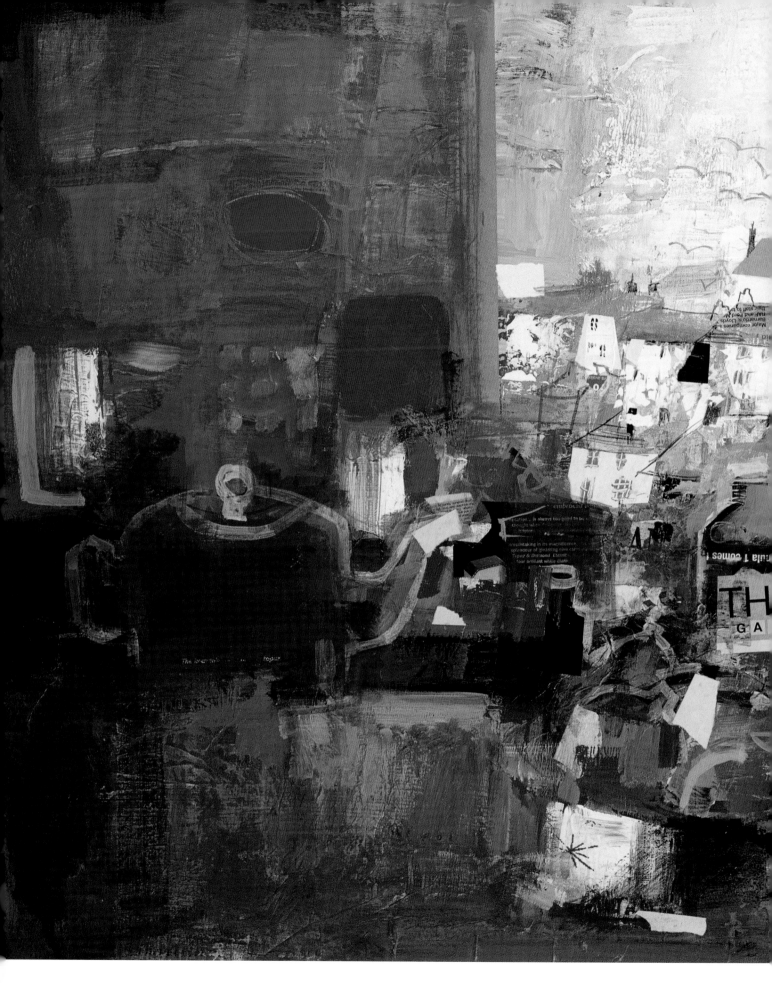

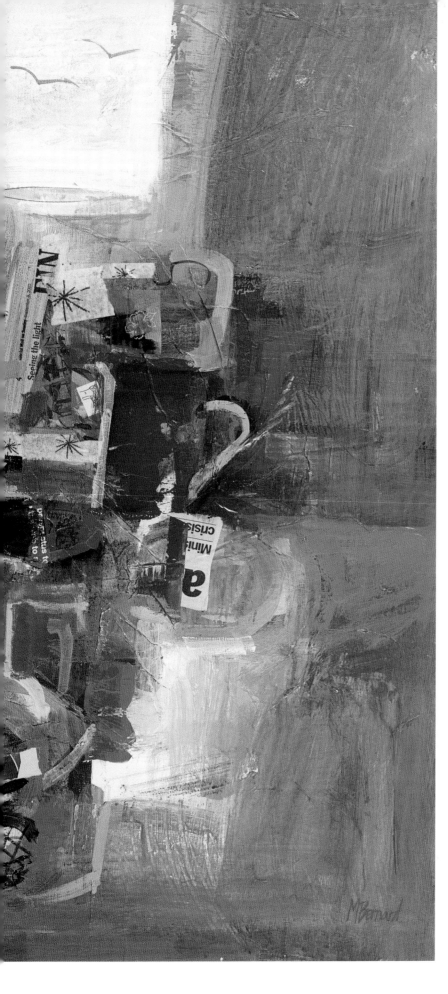

left: *Still Life and Harbour View*
mixed media on MDF
66 x 91.5 cm (26 x 36 in)
Try to think of the background as an equally
important part of the painting, in which the
shapes, colours and textures can play a
significant role in creating an exciting result.

From start to finish

Manarola

Inspiration

Often, a strong factor in the appeal of a subject is its inherent abstract qualities: I am attracted to subjects that have an obvious sense of pattern. For example, the thing I found inspirational about the Italian village of Manarola was the effect created by the way that the houses were perched on top of one another, hugging the cliff face. It was essentially this quality that I wanted to achieve in the painting. But you will notice that I have flattened the pattern effect and emphasized the vertical and horizontal divisions, creating a much more abstract result.

Technique

I decided to work on a large scale. This allowed a bold treatment, initially with large pieces of collage and strong, vertical blocks of colour applied with a roller. Other collage work was introduced later, for the palm trees, for example. Note also that I have kept to my usual restricted colour palette, with essentially a warm and a cool colour, using the same blue for the sky and sea areas, to unify the work and create a sort of 'frame' to focus interest on the buildings and landscape.

 In many of my paintings, I reach a stage when I become aware that I am beginning to overstate the content and involve too much detail. This painting was no exception, and I had to adjust and simplify some areas, mostly by working with white acrylic paint applied with a piece of card. Sometimes it is necessary to be very positive in approach and perhaps take some risks in order to re-establish the impact and harmony of a work. Simple, effective images are often much harder to achieve than straightforward representational ones. Nevertheless, in my view, it is always important to bear in mind that while the subject matter should inspire you, it should never dictate how you work.

left: *Manarola*
mixed media on MDF
76 x 91.5 cm (30 x 36 in)

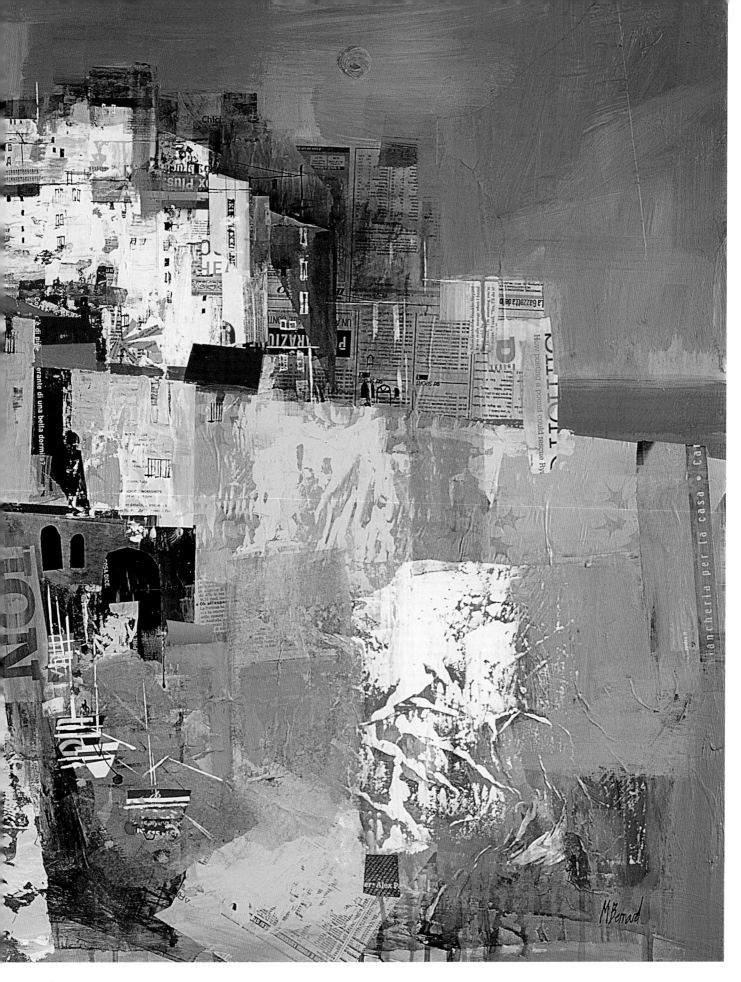

Index